TYNEMOUTH &
CULLERCOATS
THROUGH TIME
Ken Hutchinson

AMBERLEY PUBLISHING

The book is dedicated to all those who have given their lives for others while carrying out rescues for the Tynemouth Voluntary Life Brigade and the Cullercoats Lifeboat Station. All royalties from the sale of this book will be split evenly between both organisations.

First published 2011

Amberley Publishing
The Hill, Stroud
Gloucestershire, GL5 4EP

www.amberley-books.com

Copyright © Ken Hutchinson, 2011

The right of Ken Hutchinson to be identified as the Author of this work has been asserted in accordance with the Copyrights, Designs and Patents Act 1988.

ISBN 978 1 4456 0437 4

British Library Cataloguing in Publication Data.
A catalogue record for this book is available from the British Library.

Typeset in 9.5pt on 12pt Celeste.
Typesetting by Amberley Publishing.
Printed in the UK.

Introduction

Tynemouth and Cullercoats are two of the oldest settlements in the North East. Both are now popular tourist towns linked by a seafront trail used every day by thousands of locals and visitors. Over the years the villages have grown into towns and have seen many changes, particularly after the railway was built linking them with Newcastle. Landmark buildings were erected to meet the needs of tourists and entrepreneurs and then years later altered, converted or demolished and replaced as time demanded.

Tynemouth is one of the most interesting towns in Britain. It has been occupied for over 2,000 years by the Romans, Vikings and Normans, playing host to kings, monks and armies. At its name suggests the town developed where the river mouth meets the North Sea, on the north bank of the River Tyne. The striking headland, known originally as Pen Bal Crag, has been occupied for thousands of years. Its defensive qualities – steep cliffs on three sides – have made it a natural place for successive rulers to build strongholds. From a small Roman fort, to a Norman castle, to the Second World War underground defences still evident in the castle, Tynemouth has been heavily defended against the many threats from invaders through the ages.

Tynemouth has also served for centuries as a religious centre. An Anglican monastery established here by the end of the seventh century of which Heribald, a friend of the Venerable Bede, was abbot. It was raided by the Danes and destroyed in 875. Tynemouth Priory was established by Monks from St Albans as a Benedictine priory in 1085. Roman stones from Wallsend were used to build the impressive structure.

The priory has significant royal connections. It is believed that three kings have been buried in Tynemouth: St Oswin, King of Deira, in 651; St Osred, King of Northumbria, in 792 and King Malcolm III of Scotland in 1093. In later years it was also popular a stopover for royalty travelling to and from Scotland. Kings Edward II, Edward III and Richard II are all known to have stayed here.

Tynemouth was a wealthy monastery, exporting coal from its deposits, but the prior regularly clashed with the Bishop of Durham and the town of Newcastle over commercial interests. The monastery also built St Leonard's Hospital for lepers on the outskirts of the town, in what is now Northumberland Park. In 1539, following the dissolution of the monasteries, the priory was largely demolished, with the exception of the tall east-end buildings, retained because they served as a lighthouse.

The town of Tynemouth originally developed on either side of the main street leading to the castle. Front Street, the wide main thoroughfare, maintains it centuries-old appearance and contains a number of public

houses, successors of the earlier coaching inns. Shops and other services have replaced earlier businesses that served the castle and priory.

When the railways reached Tynemouth in the late 1830s, the town developed rapidly, both as a commuter town for Newcastle and as a visitor attraction. Impressive terraced houses were built by the wealthy close to the railway station or with views over the river and sea. Development continued during the twentieth century, after the new Tynemouth Station was built as part of the North Tyne Loop linking the coastline with Newcastle

Tynemouth is famous for its Volunteer Life Brigade – the first in the world – established in 1864 following a succession of shipwrecks on the notorious Black Midden rocks. Over the years, hundreds of people have been snatched from the sea by brave volunteers. The fascinating museum, displaying mementos of the countless rescues, is worth a visit. The North Pier, finished in 1909, together with the lighthouses at North Shields, have helped to prevent many shipwrecks on the Black Middens, but the power of nature still keeps the Tynemouth volunteers occupied with rescues throughout the year.

The name of Cullercoats is said to originate from 'Culfre-cots' meaning dovecotes or dove houses. The village originally belonged to Tynemouth Priory but was later owned by Thomas Dove, from whom the name may have originated.

Cullercoats, with its natural harbour, has been home to fishermen for hundreds of years and still has a small number of working boats. The Cullercoats fishwives were famous in the North East as they travelled around the area carrying fish for sale.

The caves in Cullercoats were sometimes used by local smugglers trying to avoid the excise men. The harbour has also been used to export coal from local pits and limestone from Marden Quarry, brought to the harbour by a number of waggonways that led directly to waiting ships. In addition, salt production using salt pans fuelled by local coal was important in the seventeenth century.

The beauty of the coastline and the good light has also attracted artists to Cullercoats. In the late nineteenth century, the town became an artists' colony. The most prominent artist to live here was the American Winslow Homer who painted many local scenes, making Cullercoats famous throughout the world. Cullercoats continues to attract artists and holds annual art exhibitions.

As at Tynemouth, there have been many shipwrecks in the area, which led to the erection of the watch house in 1879. The Cullercoats Volunteer Life Brigade, established in 1865, was the second in the country after Tynemouth. The Duke of Northumberland paid for the establishment of

a lifeboat in 1852 which has been operated by the Royal National Lifeboat Institute since 1853 and the present lifeboat is still operated by the RNLI.

Cullercoats was still essentially a small fishing village until the railway arrived in 1882. The railway station was quickly surrounded by streets of terraced housing to serve workers from Newcastle, and impressive new housing was built by the wealthy, overlooking the sea. The magnificent St George's Church was built in 1884, at the south end of the new housing, to serve the growing community. The seafront developed, becoming a tourist resort as well as a working harbour. The Dove Marine Laboratory was set up as a research establishment and is now linked to Newcastle University.

I was asked to write this book following the success a similar book, *Wallsend Through Time* in 2009. Again I have worked closely with staff in the Local Studies Library at North Tyneside and made use of their extensive postcard collection. I worked for North Tyneside Council for over twenty-nine years as a town planner and know both villages very well. As the Conservation Officer for the council in the 1990s I was instrumental in bidding for Lottery and English Heritage funding for Tynemouth to carry out environmental improvements over six years from 1998. In addition, I was directly involved in the scheme for the restoration of the roof and weathervane at the Cullercoats Watch House in the 1990s. I am also a member of Tynemouth Antiquarians and Historical Society who meet at King's School, Tynemouth on the second Wednesday of the month at 7.15 p.m. October– April each year; new members and visitors are always welcome.

As the book is published in colour I have used as many colour postcards as I could find from the 'golden age' of postcards between 1900 and 1918. North Tyneside Council libraries have an impressive collection of colour postcards from this period and although the range of subjects is not as wide as available in black and white postcards, I believe they have an added charm and hopefully will enhance the enjoyment of the reader. This book aims to highlight changes over the years, bring back memories of buildings that have disappeared and also show some buildings and features of the local landscape that disappeared before living memory. The pictures are arranged to follow a scenic walking route along the riverside and coastline between Tynemouth and Cullercoats Metro stations.

As with any book of this type there will inevitably be some errors, for which I apologise in advance, as I have not been able to check every name, date or detail at the original source.

Ken Hutchinson
2011

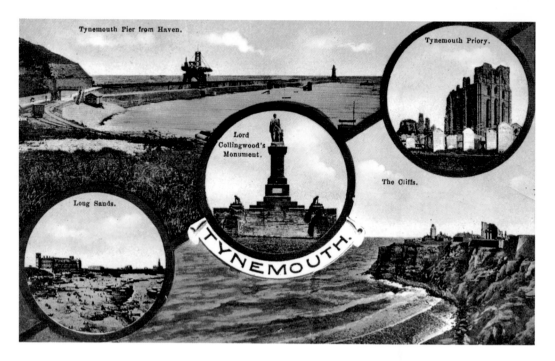

Tynemouth Views

Two early postcards advertise the attractions of Tynemouth in the early 1900s. The card above features the recently reconstructed pier, Tynemouth Priory, Longsands, Lord Collingwood's Monument and the cliffs at King Edward's Bay, showing the lighthouse that was demolished after 1898. The card below shows a tram travelling towards Colbeck Terrace and the clock tower on Front Street.

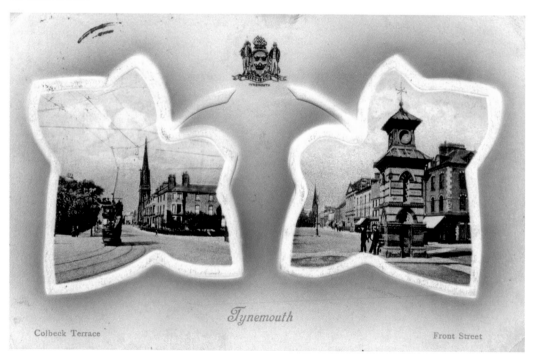

Tynemouth Station.

Tynemouth Station

The present Tynemouth Station was built in 1882 when the new Tyneside Loop was built to serve the coastal towns of Tynemouth, Cullercoats and Whitley Bay. Before this the railway terminated at a station in Oxford Street. The new station was designed for the North East Railway Company by William Bell. The attractive glazed canopies and planting give the appearance of a winter garden rather than a railway station. The old Oxford Street Station has been converted to residential flats beside new houses on the former goods yard.

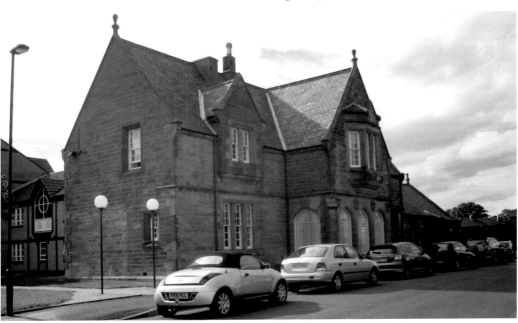

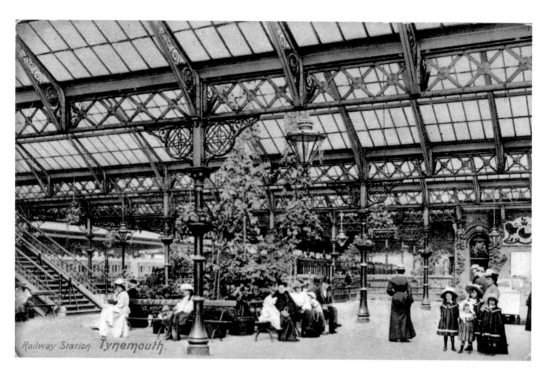

Railway Station, Tynemouth

This postcard from March 1906 features the latest fashions of the day. When the new Metro system was proposed the present station was far too big for an operational halt and demolition was suggested. This caused an outcry and the Friends of Tynemouth Station was set up to encourage the restoration and reuse of the buildings and canopies. This led to a restoration scheme for the central area in the 1980s led by North Tyneside Council. Markets now make use of the space.

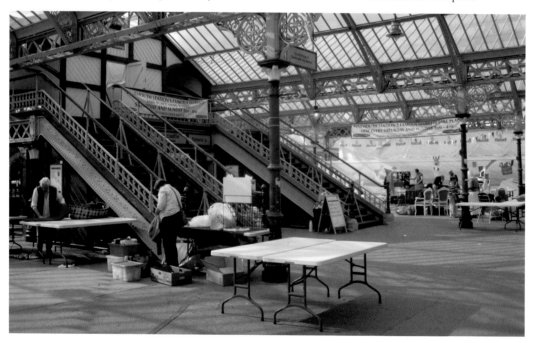

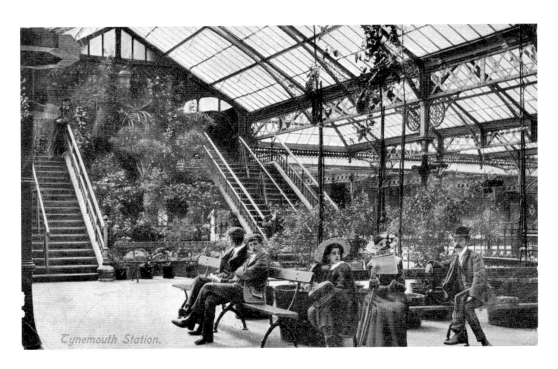

Tynemouth Station.

Tynemouth Station Staircase

Postmarked 14 August 1906 this postcard provides us with a detailed glimpse of the care taken by station staff to make the railway station as attractive as possible to customers. The extensive vegetation between the main staircases to the overpass would greet all passengers entering the main entrance of the station from Tynemouth. In 2011 work started on the restoration of the remaining derelict canopies, to complete the scheme started in the 1980s. A few plants would certainly not go amiss in the future.

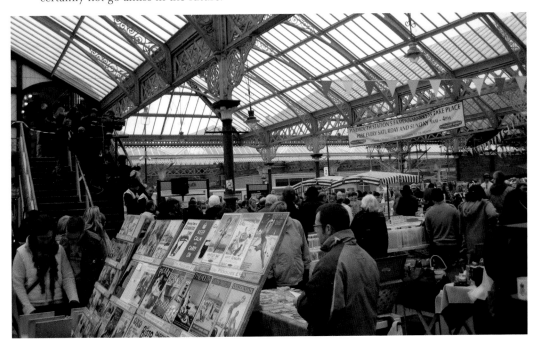

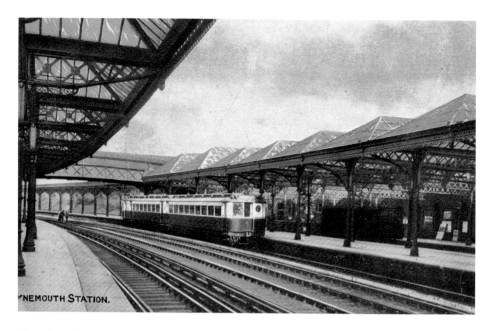

NEMOUTH STATION.

Electric Trains at Tynemouth Station

Electric trains were introduced onto the Tyneside Loop railway in 1904. They were a new innovation following the recent development of electricity and a very early example of green technology at a time when steam trains were polluting the rest of Tyneside. They were remarkably similar in appearance to the Metro tram introduced in 1980, although the modern system has overhead lines replacing the previous trackside electric rails. The later picture shows a Metro tram at the station during the 2011 restoration scheme.

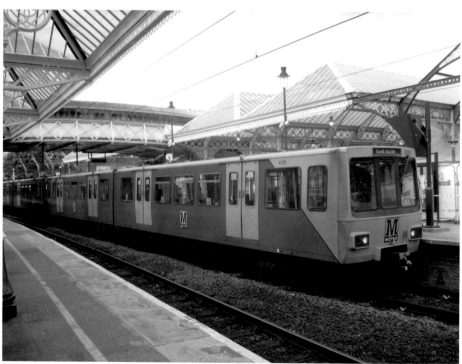

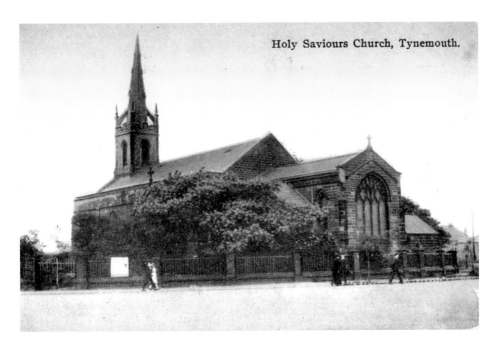

Holy Saviours Church, Tynemouth.

Holy Saviour's Church, Tynemouth

Holy Saviour's was designed by John and Benjamin Green of Newcastle and built between 1839 and 1841 for the Duke of Northumberland. The postcard is dated from the 1940s when the spire was still in existence. The railings around the grounds were later removed as part of the war effort. In recent years, the church hall was added to the east side to replace an earlier detached hall and to provide modern meeting rooms and facilities for the present congregation.

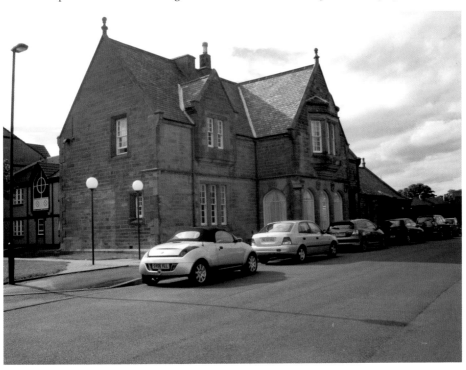

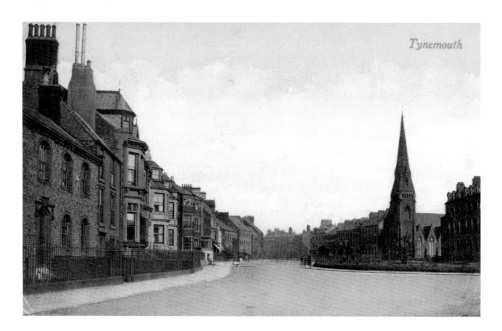

Front Street, Tynemouth Looking East over The Green

Dated 1909, the views over The Green are not interrupted by the established trees now surrounding the green open space. The building on the left, No. 1 Front Street, is the former house of the Duke of Northumberland's agent; the Percy family's crescent moon badge is still evident above the door and on the gate. Most of the adjoining large houses in Front Street were built following the arrival of the railway in the village attracting well-to-do residents now able to commute to Newcastle. King's School is on the right beside The Green.

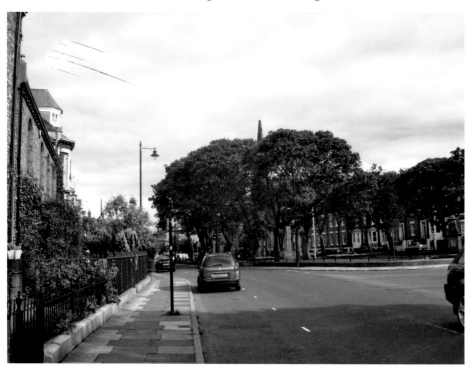

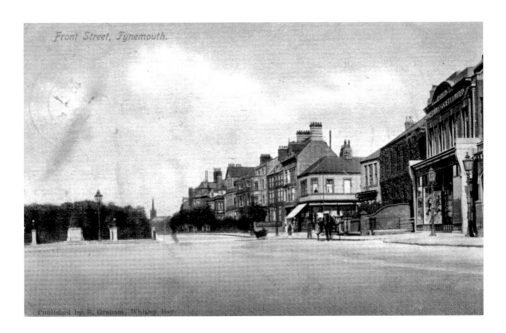

Front Street, Tynemouth.

Published by R. Graham, Whitley Bay.

Front Street, Tynemouth Looking West to The Green

The postcard dates from before November 1905, the date of the postmark. The only traffic in view is a horse and cart outside the property now known as 'Raspberry Bazaar'. Queen Victoria's monument, sculpted by Alfred Turner, can be seen on the left of the postcard only a few years after it was placed there in 1902, the year after her death. The picture below shows an attractive flower bed with stone piers and railings, installed over a century later as part of the environmental improvements carried out to reinvigorate the village.

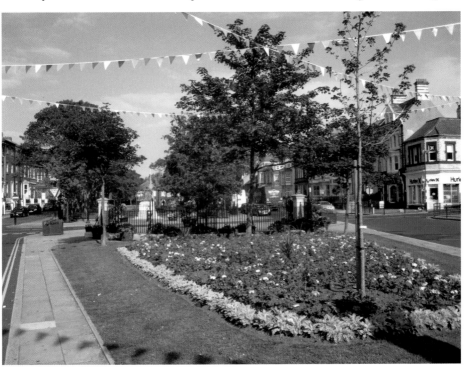

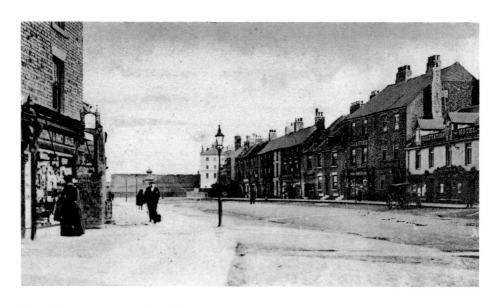

Front Street, Tynemouth Looking East

The postcard dates from around 1910. Just off picture to the left was the studio occupied by Mathew Auty who produced thousands of postcards for the rapidly developing market. He was one of the first to feature local scenes and many of the postcards in this book were produced his company. The white building on the right is the Salutation Hotel with the rare sight of a motor car standing outside. Notice that in 1910 buildings extend all the way along the south side of Front Street; there is now a gap site in front of Our Lady and St Oswin's Church.

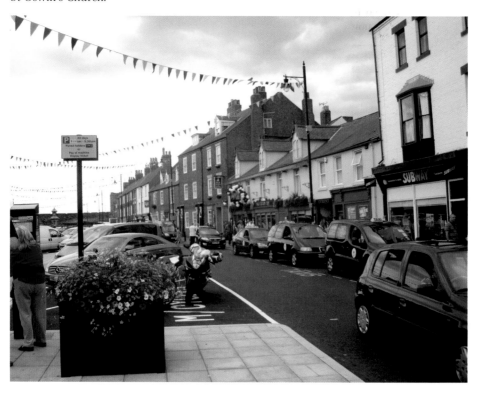

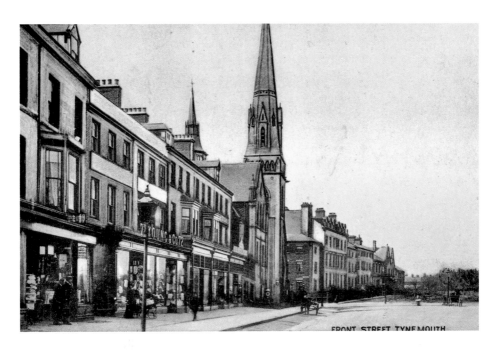

Front Street, Tynemouth – South Side Looking West

Looking towards the congregational church with Huntington Place beyond, this postcard is dated April 1907. The congregational church was built in 1868 and was designed by Thomas Oliver of Newcastle. The spire was built in 1873. It is now used as a shopping centre and the former church hall, built after 1884, is now a pub and restaurant. The shop at 72 Front Street was occupied by Young & Co. in 1907 and a lady can be seen outside pushing a perambulator. It is now occupied by a supermarket.

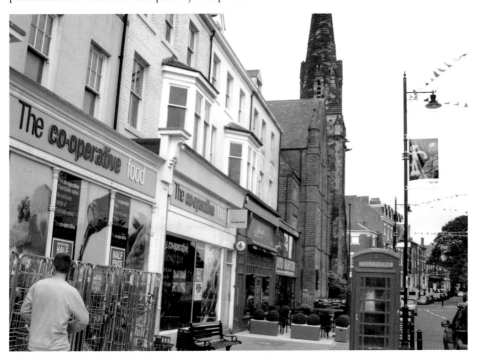

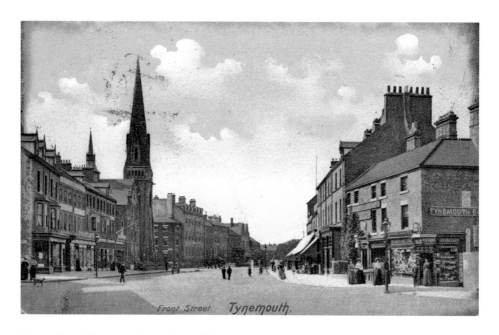

Front Street, Tynemouth Looking West

This early postcard postmarked July 1904, shows a shop on the corner of the junction with Hotspur Street with a pub behind it. Today the Percy Arms occupies the whole of this site. The lack of vehicles, with the exception of the horse and carriage in the distance in front of Huntington Place, emphasises the width of the street. The trees on The Green look newly planted and do not screen the buildings of King's School as they do today.

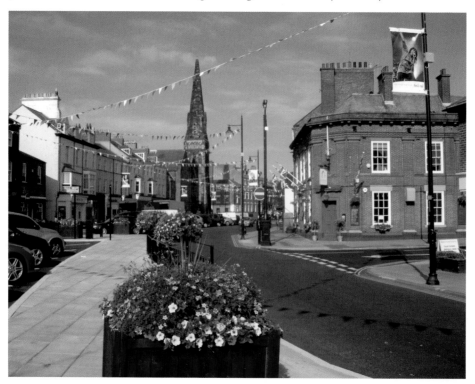

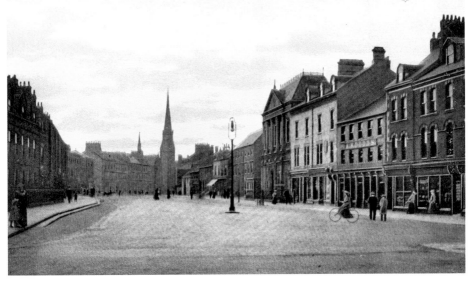

Front Street, Tynemouth from the East

This view dates from around 1910. The lady in the foreground is demonstrating just how safe it was to cycle on Front Street in those days. To the right of the lamppost is an imposing building that was the Wesleyan Methodist church. It later became the Carlton Cinema. The building was demolished in the 1980s and Timothy Duff Court was built on the site adjoining the present library. The Turk's Head public house now occupies the site of the former shop with the A. N. Dodds sign above.

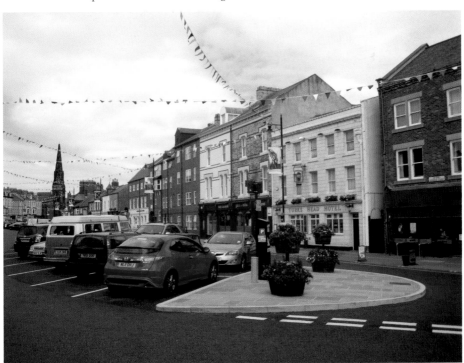

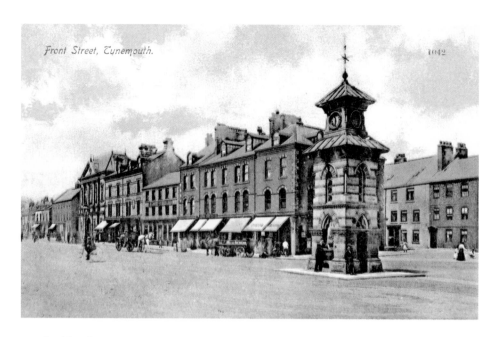

Front Street, Tynemouth. 1042

North Side of Front Street and the Clock Fountain

This view of the east end of Front Street shows the original shop buildings on the north corner of Front Street and East Street, with houses in Middle Street behind. The area was cleared after the Second World War and the open space was used as the East Street car park for years up to the 1990s when the present East Street housing site was built. The clock fountain was renovated in 1999 and the pavement was extended around it as part of the Conservation Area Partnership environmental improvements in front of the Castle.

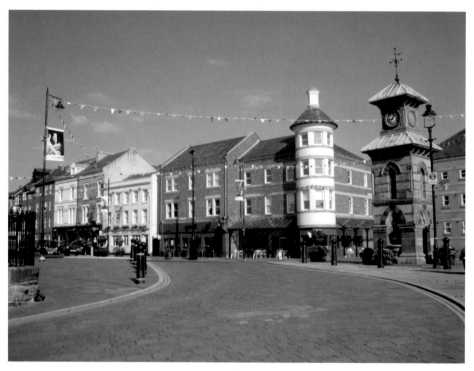

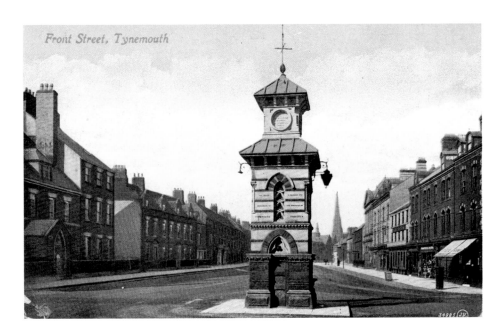

Clock Tower, Front Street Looking West

The postcard is dated August 1905 and features the landmark clock fountain at the east end of Front Street. It was presented to Tynemouth in 1861 by William Scott of London, in gratitude for the improvement in his health following a stay in Tynemouth. This magnificent Venetian Gothic-style clock tower and drinking fountain also boasted a thermometer and a barometer. The lamp hanging from the north side is thought to be a red lamp hung from the structure when the Life Brigade was on watch.

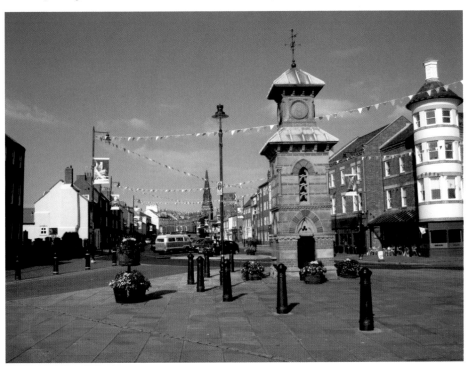

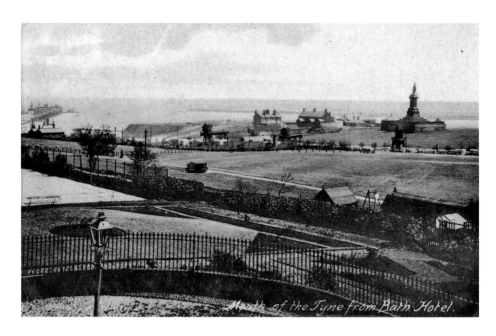

Mouth of the Tyne from the Bath Hotel

This view from the former Bath Hotel at the east end of Bath Terrace, known in later years as the Royal Sovereign pub, was taken before June 1908. It shows construction taking place on the North Pier and includes the pier works building compound, or stockyard, along the side of the railway line leading from the Oxford Street depot to the pier. Piles of stonework are stored beside the track, presumably unloaded from the three gantries in view. The pier was opened in 1909.

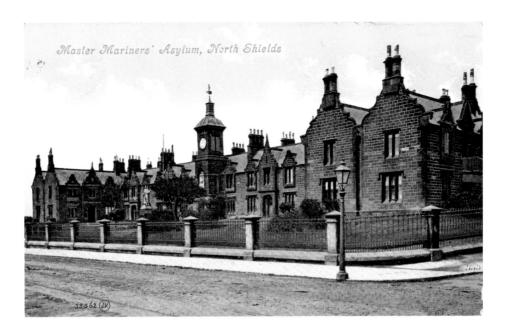

Master Mariners' Asylum

This view dates from before April 1908 and shows the Master Mariners' Asylum, which was designed by John and Benjamin Green and built in 1837 on land owned by the Duke of Northumberland. They were built as almshouses for former master mariners and their families in Tudor style. There is a fine statue of the Duke of Northumberland outside the main entrance. It was sculpted by C. Tate and finished by R. G. Davies after Tate's death in 1841. In recent years, the buildings have been modernised, bringing them up to date but still retaining their original appearance.

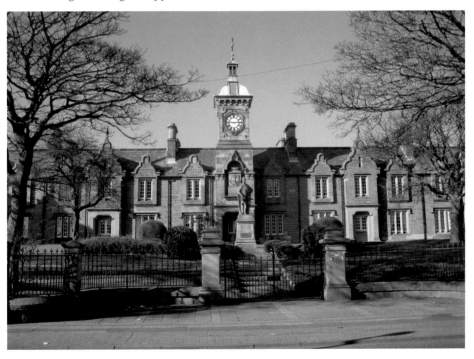

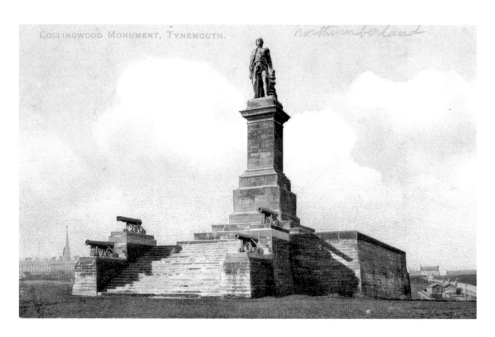

Collingwood's Monument

The postcard is dated June 1905. Admiral Cuthbert Collingwood is the true victor of the Battle of Trafalgar in 1805. As his good friend Nelson lay dead, Collingwood assumed command of the British fleet and defeated the French and Spanish navies. Collingwood led the way in his ship the *Royal Sovereign* (from which the cannon came) and one of the last things Nelson did before he was shot was praise the courage of his fellow admiral as he cut through the enemy lines. He is buried beside Nelson in St Paul's Cathedral in London.

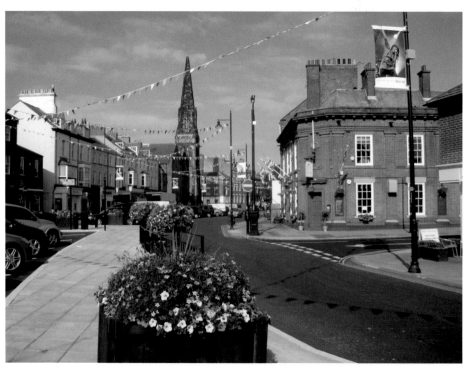

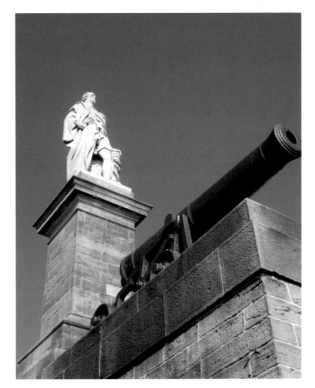

Lord Collingwood's Monument
The monument was erected in 1845–7. It was designed by John Dobson and the statue was sculpted by J. G. Lough. Collingwood was born in 1748 in Newcastle and attended the grammar school there, before going to sea aged just twelve. He worked his way up through the navy to become a highly respected admiral and a good friend of Nelson. He married Sarah Blackett and had two daughters but saw little of them, as he spent forty-four of the forty-seven years he was in the navy at sea. He died at sea in 1810 shortly after he became Lord Collingwood.

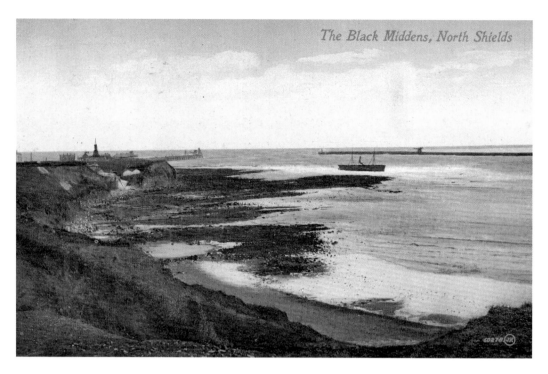

The Black Middens, North Shields

The Black Middens

The Black Middens is the name given to an area of rocks in Tynemouth, close to the north bank of the Tyne and the Spanish Battery. The rocks were notorious for shipwrecks, as they lay just below the river at high tide and often ships were blown on to them in heavy winds as they entered the river. Many ships were stranded as above, within sight of the shore, and many lives were lost. This led directly to the establishment of the first Voluntary Life Brigade in Britain at Tynemouth in 1864.

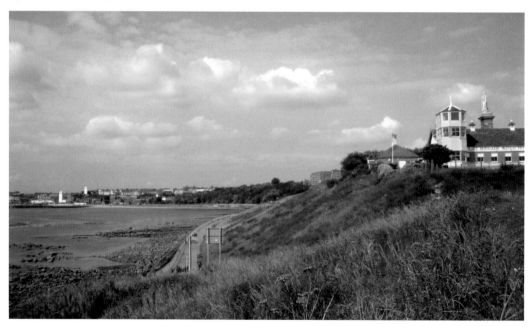

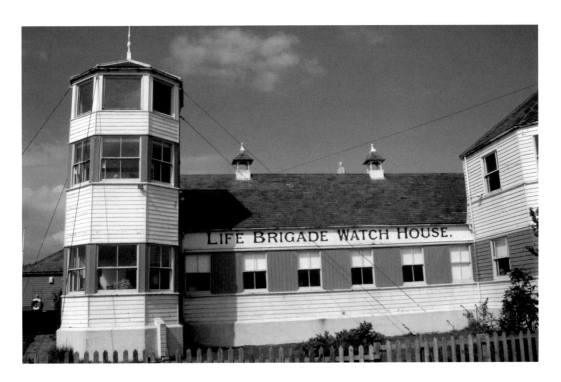

Tynemouth Lifeboat

The Tynemouth Volunteer Life Brigade (1887, Watch House, above) was set up after the schooner *Friendship* and the SS *Stanley* were shipwrecked on the Black Middens, on 24 November 1864, with great loss of life and watched from the shore by helpless onlookers. The original Tynemouth lifeboat, *Constance*, was based in Priors Haven and was involved in the rescue that night, with the loss of two men. In 1865 a second lifeboat was based on the Black Middens. This picture is thought to be of a later lifeboat, *Forester*, from around 1898.

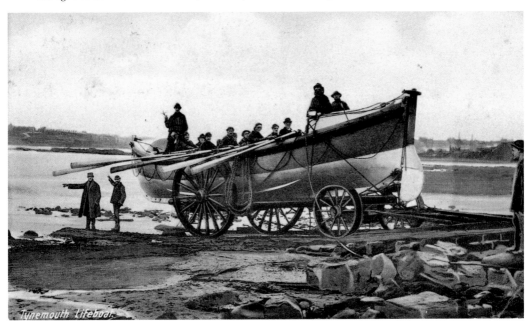

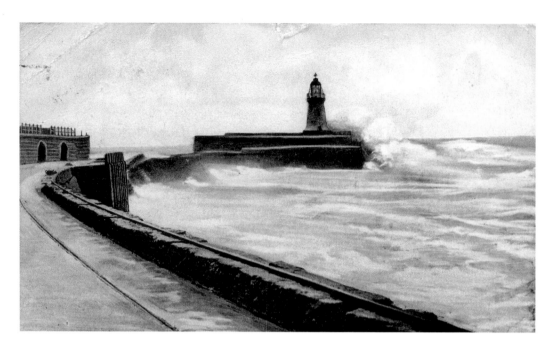

Tynemouth Pier Damaged

Work commenced on building the North Pier in 1855, carried out by the recently established Tyne Improvement Commissioners. The original design was for a curved structure to match the South Pier, being built at the same time. The construction proved difficult and the pier gradually extended into the river mouth over the years, finally reaching completion in 1895. Only two years later, in 1897, storms battered Tynemouth and breached the pier over the distance of one hundred yards, stranding the lighthouse. Recent storms in July 2011 also show the power of the sea.

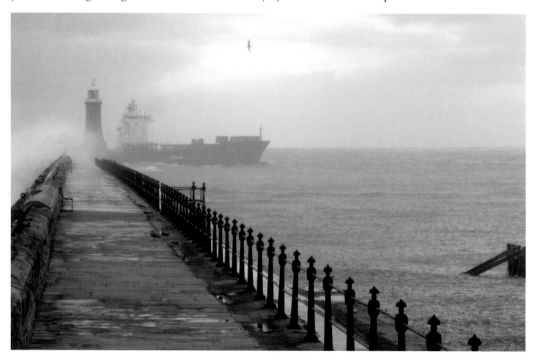

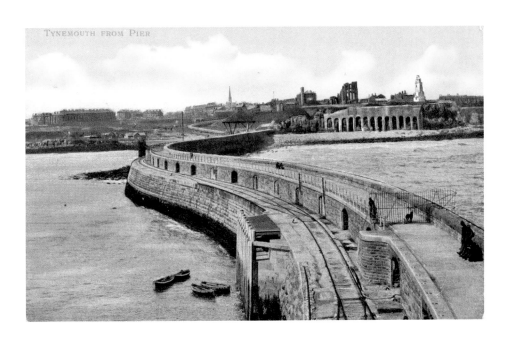

Curved North Pier with Priory Lighthouse

This postcard clearly shows the extent of the curve on the original pier compared with the present one. A fence is erected across the pedestrian walkway to prevent visitors from entering the damaged section of the pier. In the distance, the lighthouse is clearly visible on the Tynemouth Priory headland, which means the picture must date from before 1898 when the lighthouse was removed. The lighthouse was built in 1775 and went out of use in 1898 when St Mary's Lighthouse opened in Whitley Bay.

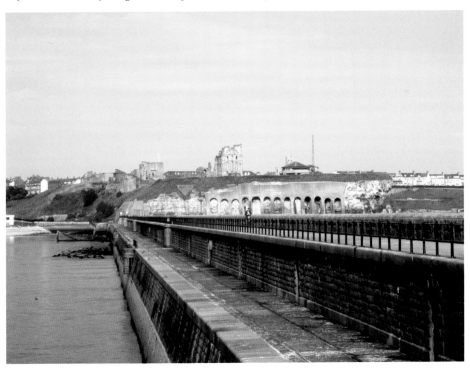

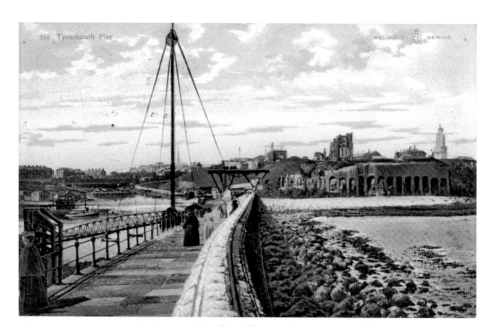

Tynemouth Pier Looking Towards the Priory and Lighthouse

This postcard is dated August 1905 and shows the point where the old pier started to curve. Several ladies are shown promenading along the pier with parasols to protect them from the sun. A number of structures are evident on the pier, presumably linked with the ongoing reconstruction works. The lighthouse at the priory still stands, and below it on the cliffs we see the concrete retaining walls that were built to protect the eroding Pen Bal Crag in the late 1890s. The recent picture shows the point where the old pier meets the new and the old crane rails end.

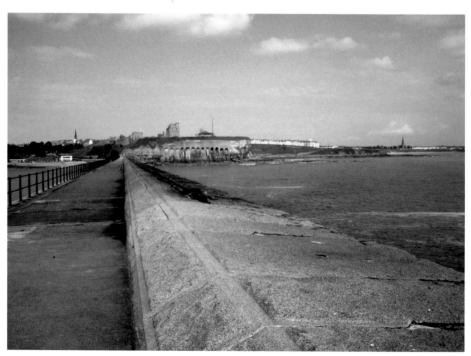

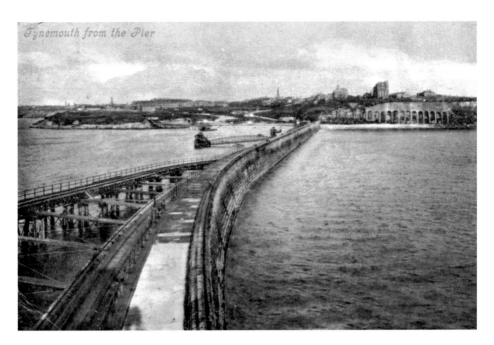

Tynemouth from the Pier

Tynemouth Pier Looking Towards the Priory with the Second Construction Pier

Postmarked July 1905, this postcard shows the second construction pier in position, following the straight line of the new pier. In the distance the lighthouse at Tynemouth Priory has now been removed. The peninsular behind the pier to the south of Priors Haven is known as the Spanish Battery, a name it was given in the sixteenth century when it held a fortified battery manned by Spanish mercenaries. At the time one of the main threats was from the Dutch, whereas now a ferry from Amsterdam is warmly welcomed between the piers every day.

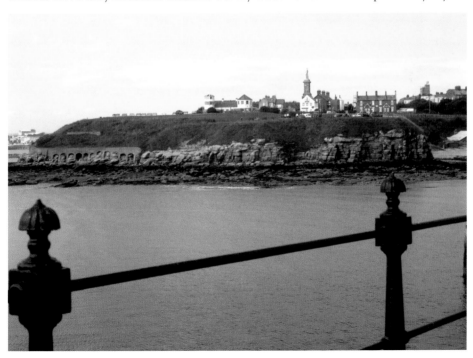

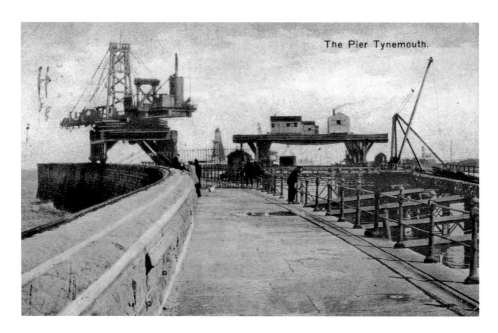

Tynemouth Pier and Cranes During the Construction of the Second Pier
The reconstruction of the North Pier is well underway, as shown on this postcard, from about 1904. The large Titan crane is seen utilising the existing curved pier on the left and the crane on the right with huts on top can be seen moving a heavy block into position to form the new, straight pier, which was finally completed and opened in 1909. The old pier was kept in position to provide added protection from the waves during construction. For a period of time around 1907 there were two lighthouses after the new one was built.

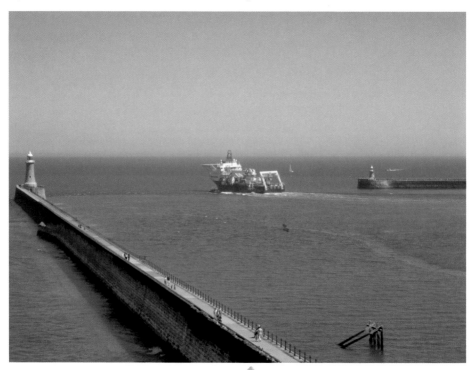

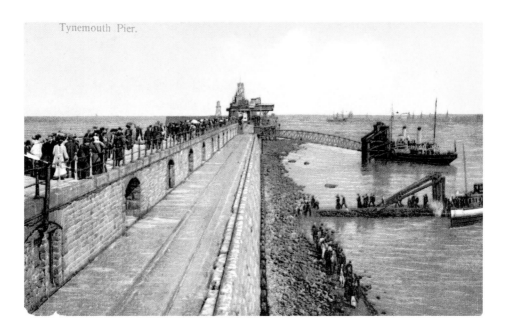

Tynemouth Pier Pleasure Boats

Pleasure boats quickly became an established feature of the pier in the early 1900s and crowds flocked to the pier to use both landing stages. This postcard is postmarked June 1906. Visitors could travel either along the coast or up river to Newcastle. The Tyne General Ferry Company was one company who offered trips from the pier to Newcastle up to 1908. The remains of the lower landing stage are still in existence after more than 100 years, but pleasure cruises from the pier ceased many years ago.

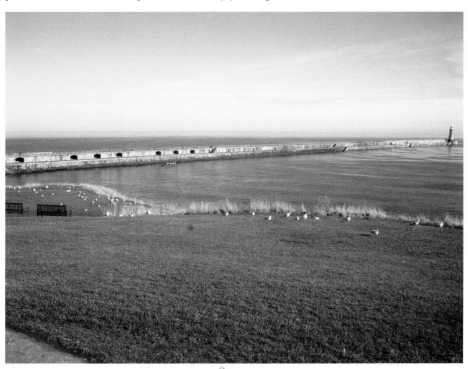

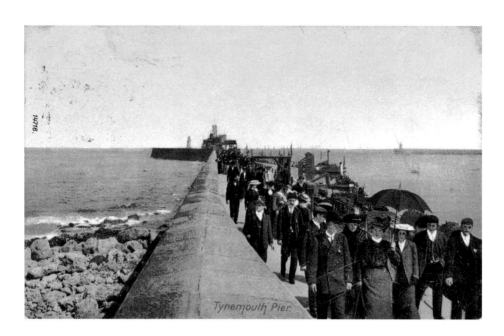

Promenading on Tynemouth Pier

Dozens of people are seen promenading along Tynemouth Pier, presumably after a trip on the pleasure boat, seen in the background tied up to the landing stage. From the looks on their faces it was not a rough passage and from the number of people involved it certainly seemed to be a popular pastime. The postcard is dated October 1906 and in the background the old curved pier is still in existence as are the cranes constructing the new pier. The picture below shows people using the pier for recreation in August 2011.

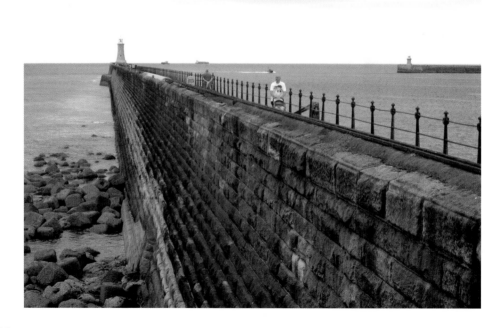

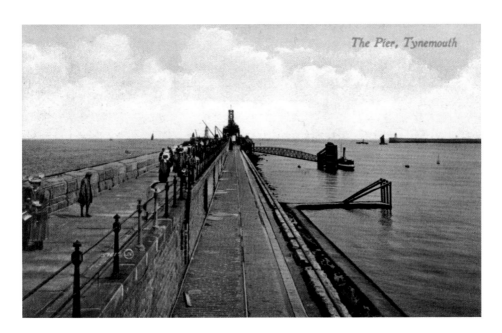

The Pier, Tynemouth

Tynemouth Pier

This postcard is postmarked 1911, about two years after the new, straight pier was opened. The picture itself must have been taken a few years earlier, as the construction cranes can still be seen in the distance and the old lighthouse is still visible to the left of the crane. The old lighthouse was demolished in 1908 after the new pier lighthouse was constructed and in operation prior to the official opening in 1909. Below, the old railway lines can still be seen on the present pier a hundred years later.

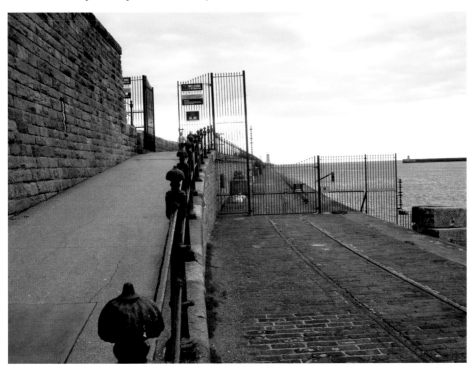

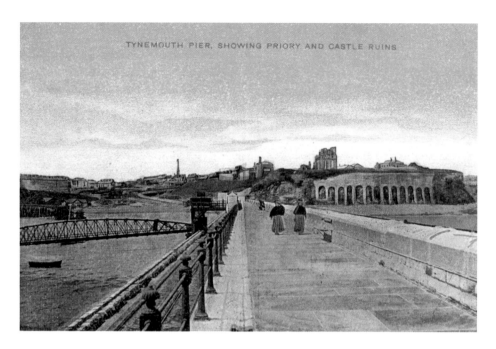

Tynemouth Pier Looking Towards the Priory

Two ladies are seen strolling along the North Pier close to the passenger landing stage that leads to the jetty serving the pleasure boats. Tynemouth Priory is on the right, a number of military buildings are visible, and Priors Haven and Spanish Battery are on the left. In the distance, the steeple of the congregational church dominates the village of Tynemouth. The picture below shows the effect of over one hundred years of weathering on the metal rails and loops on top of the pier walls.

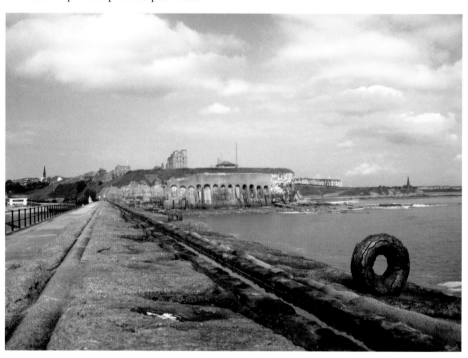

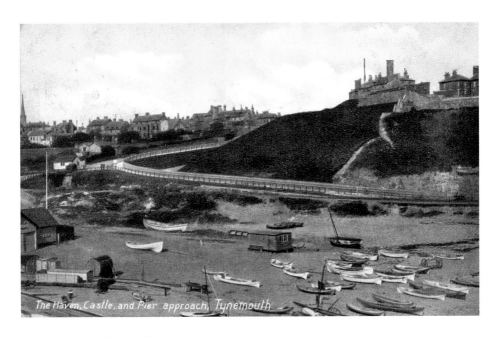

The Haven, Castle, and Pier approach, Tynemouth

The Haven, Castle and Pier Approach

Priors Haven is seen here before 1905. The beach was being used, as it is now, to store small boats including fishing, rowing and sailing craft. The sailing club had not built its clubhouse at that time. The building to the left is part of the boathouse of the Tynemouth Rowing Club established in 1867. The slipway for the lifeboat is seen in the bottom left-hand corner and the 1862 lifeboat house is just off picture. From 1807 until 1894 the vacant land to the north of the rowing club was occupied by seawater baths associated with the Bath Hotel.

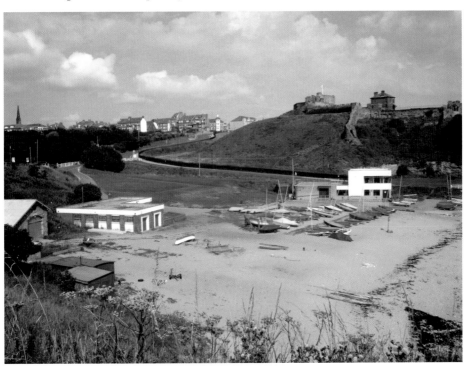

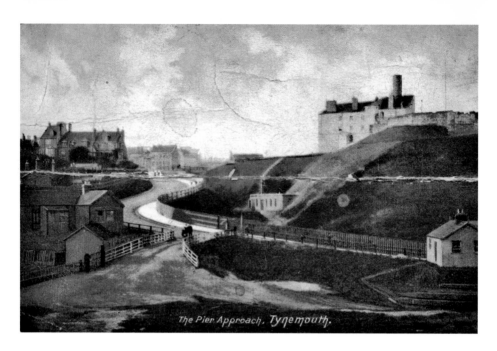

The Pier Approach, Tynemouth.

The Pier Approach, Tynemouth

This old and damaged postcard shows the pier approach just beyond the bridge over the railway line. The railway came from the block yard, where the blocks for the pier were delivered and made ready for use in construction. The block yard was quite extensive, stretching back beyond Collingwood Terrace to the edge of the cliffs in an area known as The Howlings, with another railway line leading up to the goods yard at Oxford Street. There is also a building within the old moat area of the castle, below the gateway barracks.

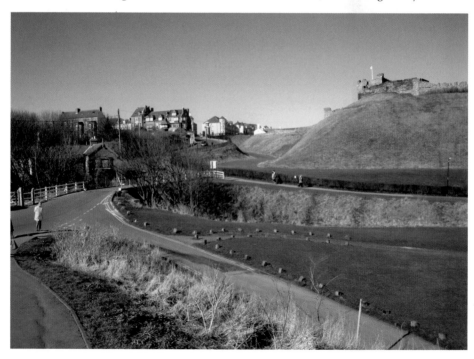

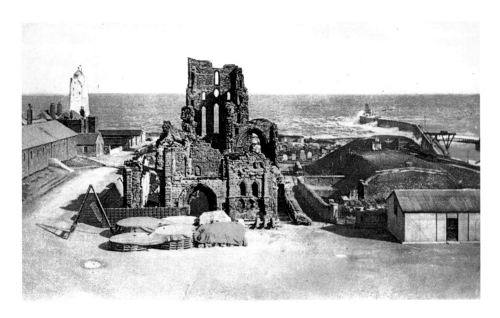

Tynemouth Castle Yard with the Lighthouse and Curved Pier Beyond

The picture dates from before 1898, as the lighthouse was demolished in that year. In addition, the curved pier is visible in the background before it was breached in 1897. The castle yard is being used to store military equipment in front of the old priory church and to the left are a number of barrack buildings all of which have now been removed. Twentieth century guns and defences remain on show to visitors. A new coastguard station was erected in the 1980s but fell out of use in the 1990s.

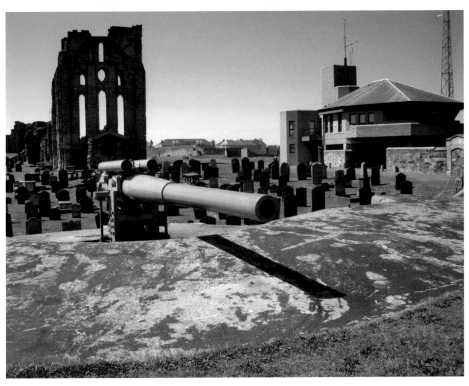

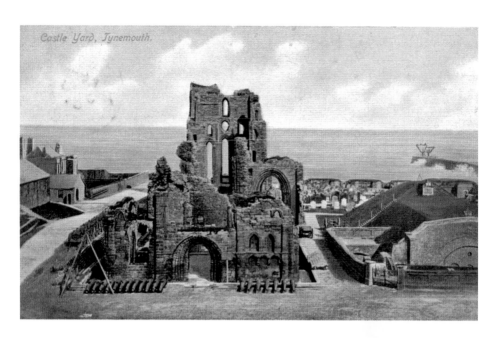

Castle Yard, Tynemouth.

Castle Yard from the Gateway

The postcard is postmarked July 1904 and shows the castle yard after the lighthouse was demolished in 1898. To the right of the priory buildings is the brick magazine built in 1863 to store ammunition. This was built on the site of the cloisters of the monastery. English Heritage has now marked its outline on the site. The brick building in the later picture is one of the former officers' houses. The military left the site in 1960 and English Heritage took over in 1984.

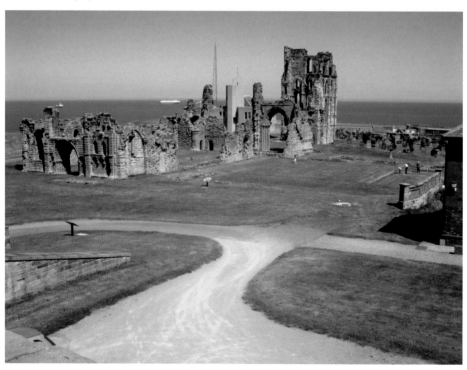

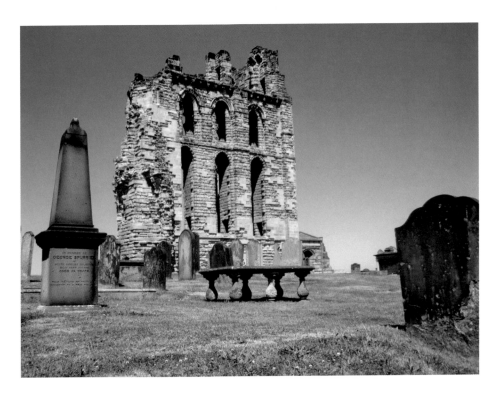

Tynemouth Priory from the Graveyard

Tynemouth Priory was established in 1085 as a daughter house to St Albans Monastery. It became a shrine to St Oswin who was buried on the site in 651, one of three kings buried at Tynemouth. The monastery became wealthy and over the years entertained royalty on a number of occasions. Much was demolished following the dissolution of monasteries in 1539 but the high east end of the church was retained as a lighthouse. The Percy Chantry on the east end was built in the fifteenth century and survived as it was used as a gunpowder store.

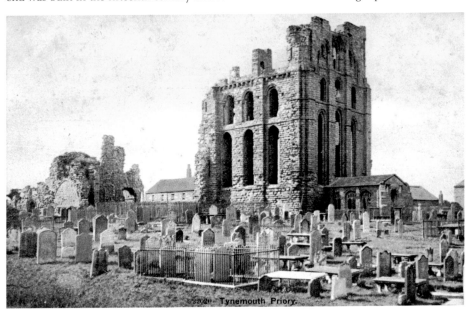

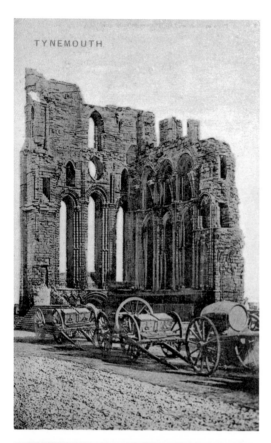

Tynemouth Priory with Ammunition Wagons

This postcard, postmarked August 1907 seems a strange card to send to friends as it features ammunition wagons laden with cartridge boxes and a barrel of powder set against the background of a religious ruin. The card was sent to Miss Thompson at Longframlington by a friend having a very nice holiday at Tynemouth with fine weather. 1900–1918 was the golden age of postcard-sending; they were the equivalent of a text message today and the postal service must have been very reliable at the time.

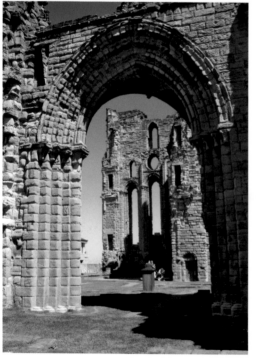

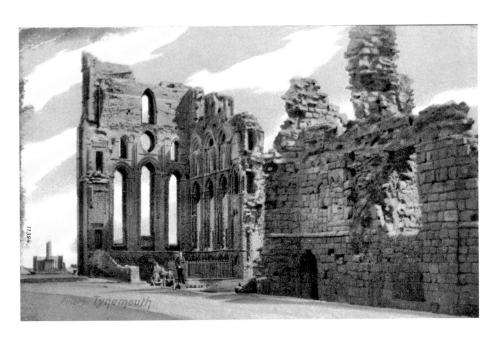

Priory and Parish Church Remains

Following dissolution, the church of the original monastery was retained as the parish church of St Mary for Tynemouth. As it was inside the castle defences it was well protected but in later years those parishioners living outside objected to having to share the church with a military camp, especially when it was used to store artillery. A decision was then taken to build a new parish church, designed by Robert Trollop, at Christ Church in North Shields. The new building opened in 1668 and the former church became a ruin.

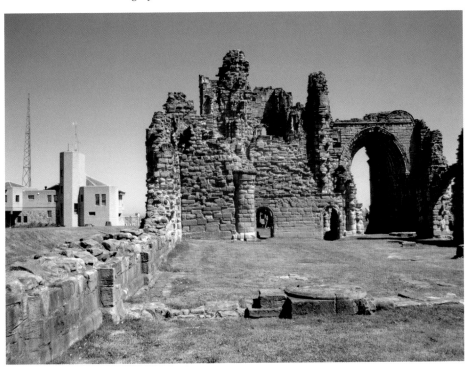

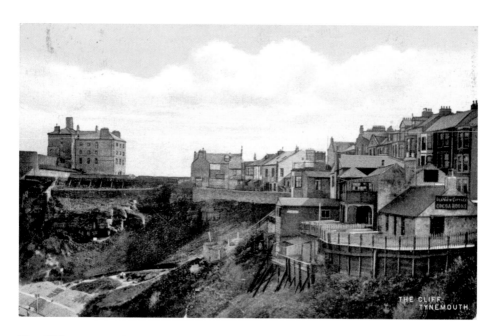

The Cliff, Tynemouth Looking South to the Castle Gatehouse and East Street

Almost all of the buildings in this picture have been demolished or changed beyond recognition. The gatehouse to the castle has been built up over the original structure and converted to barracks. Following a fire in 1936, more recent additions to the gatehouse were removed to display the original gateway as seen today. All the buildings hanging over the cliffs of King Edward's Bay fronting on to East Street have been removed with the exception of the present Gibraltar Rock and that has been considerably renovated.

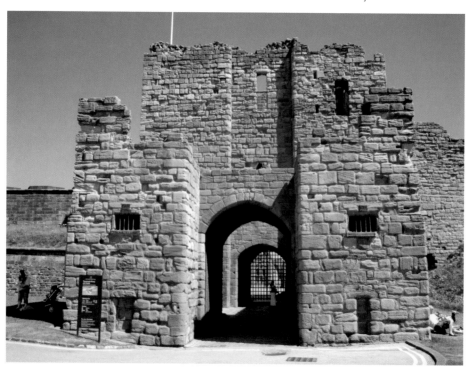

Back of East Street Tynemouth

As Tynemouth developed from Front Street, local people would build their houses and businesses as close to the castle as possible. Development grew up on both sides of East Street and buildings were built on the cliff top and sides in a variety of materials and styles, as seen above. In 1934 the council cleared the properties on the east side to widen the main road and also landscaped the bank side. The decision was probably prompted by a nearby landslip in 1913. The East Street housing development was built in the 1990s.

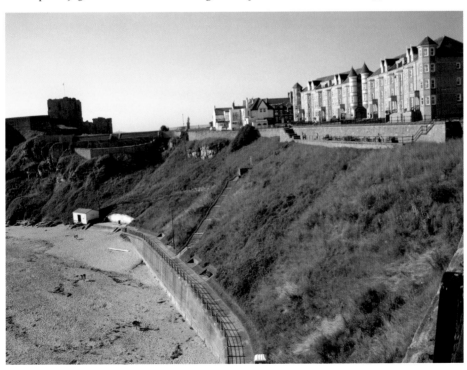

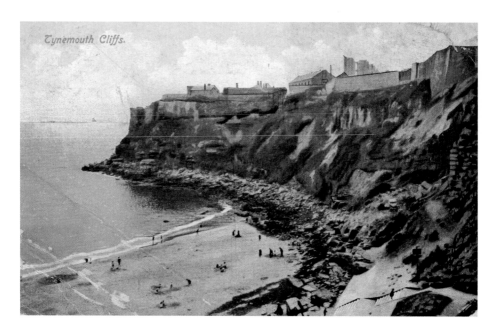

Tynemouth Cliffs, King Edward's Bay

Tynemouth Castle is protected on three sides by sheer cliffs, but still has a major defensive wall built up around the top of the cliff, as seen on the north side overlooking King Edward's Bay. This card was posted in February 1909 and at that time there were still many military buildings within the fort. Those visible over the walls were mainly barracks. A set of steps going down into the bay can also be seen, but there is no evidence of the lower promenade.

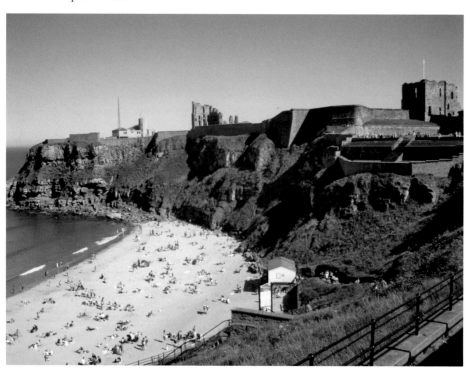

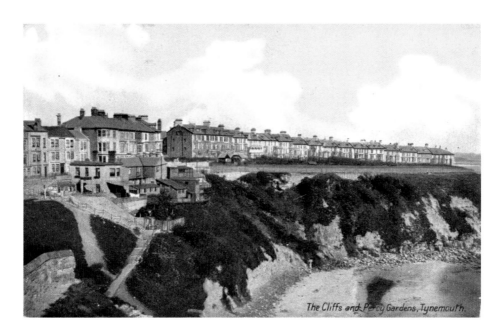

The Cliffs and Percy Gardens, Tynemouth.

The Cliffs and Percy Gardens Before the Landslip

This view looks over King Edward's Bay towards Percy Gardens and the bank side properties on East Street. There was a major landslip directly in front of the gardener's lodge in 1913, resulting in the collapse of part of the main road around the bay. Percy Gardens was built in stages from the 1870s by individual builders. It has its own private road, gardens and lodge. There was a gap in the crescent that was not built on at the time and this stood vacant until the 1960s when a controversial modern, flat-roofed infill development was built.

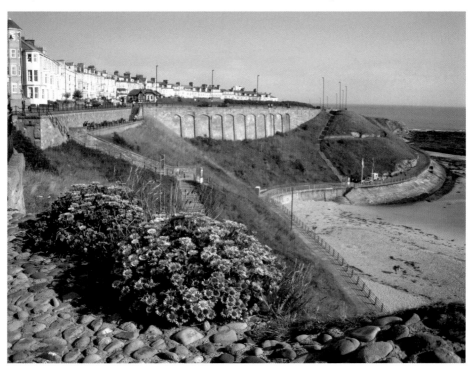

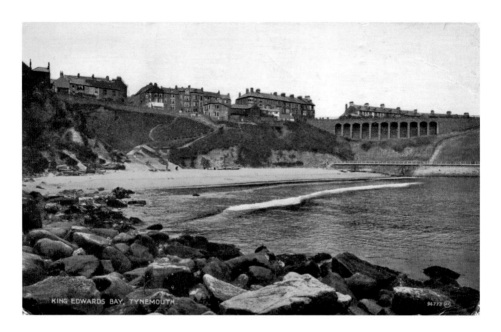

KING EDWARDS BAY, TYNEMOUTH.

King Edward's Bay

The postcard is postmarked August 1930. The landslip of 1913 has been rectified by building a section of the cliff-side road on massive arched supports with a new section of promenade below extending around the bay to the north. The housing on the bankside was finally cleared in 1936, to improve the road, extend the promenade and landscape the cliff sides. The large open arches were enclosed in the 1990s and finished in stone to give them a more visually acceptable appearance within the Tynemouth Conservation Area.

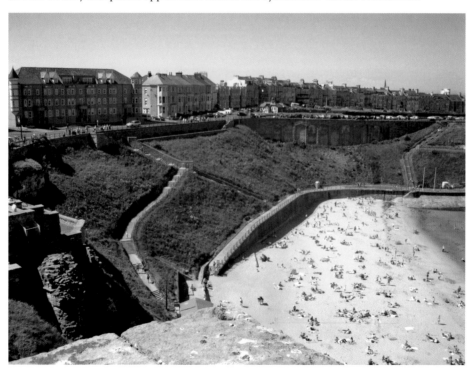

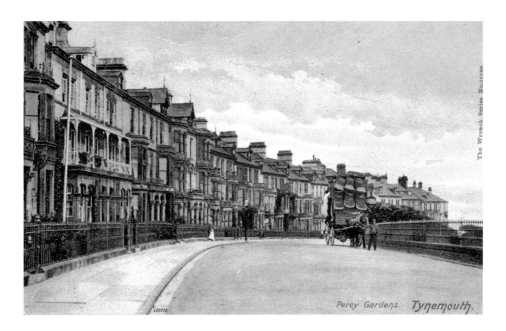

Percy Gardens

Percy Gardens, like so many streets in Tynemouth, derives its name from the Percy family, who have been Dukes of Northumberland since the 1750 and owned Alnwick Castle from the fourteenth century. They have owned large expanses of land in the area and still do; many buildings featured in the book have direct or indirect links to the family. This imposing crescent is seen before 1904 and still has its original railings, unlike the present Percy Gardens. Flat-roofed dormers and parked cars undermine the appearance of the crescent.

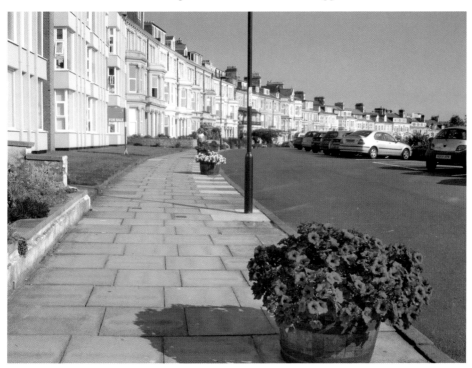

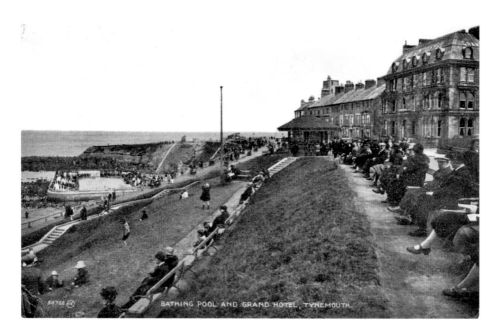

Bathing Pool and Grand Hotel, Tynemouth

This view, which dates from after September 1927, looks south towards the newly opened outdoor bathing pool with the Grand Hotel on the right. To the left of the Grand Hotel can be seen the lookout tower behind Percy Gardens. An interesting relic of the First World War, the former lookout station is now a house. It is interesting to note how well dressed all the visitors are on their expedition to Tynemouth, as they sit looking over the bay on the distinctive seats, many of which have survived today. The pool is now laid out as a rock pool.

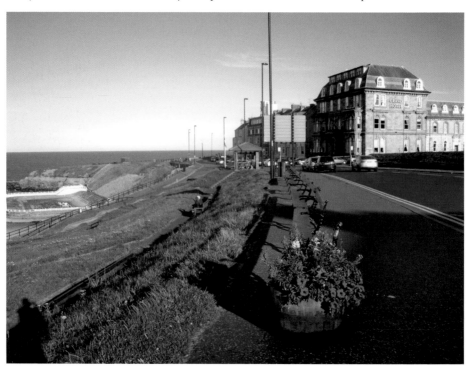

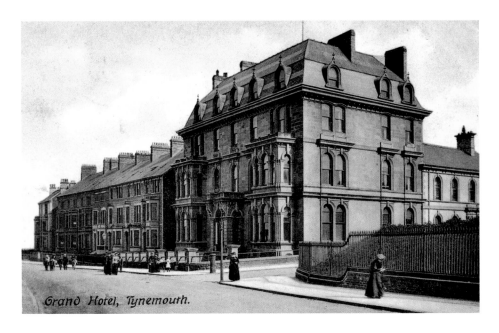

Grand Hotel, Tynemouth.

The Grand Hotel

Seen here before August 1905, the Grand Hotel was originally built as a summer residence for the Duke and Duchess of Northumberland in 1872 on land owned by the Duke. It is situated on the corner of Hotspur Street, another name linked with the family. Harry Hotspur was so famous in his day that he featured in a Shakespeare play. The family only used it for a few years before it was converted to The Grand Hotel in the late 1870s. It has continued as a hotel since, apart from during the First World War when it was used by the military. The lookout tower dates from 1913.

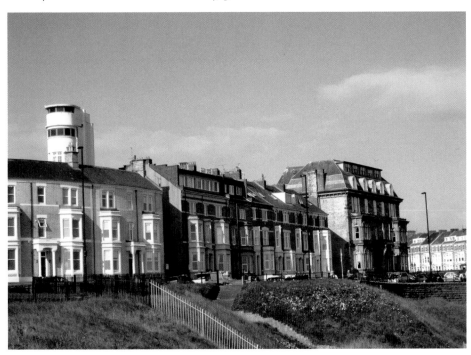

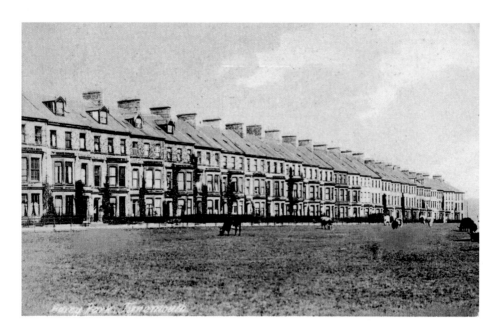

Percy Park, Tynemouth

Percy Park is another impressive terrace of property developed by the Duke of Northumberland in the late 1900s and built to a standard design by individual builders. There was great demand for new housing in Tynemouth following the arrival of the railway. Living beside the sea and commuting to Newcastle was very desirable and remains so today. The terrace overlooks a large, triangular open space. Being used by cattle around 1908, it was used to build underground air raid shelters during the Second World War and is now open space.

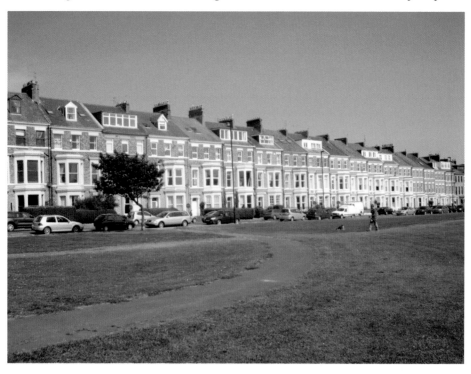

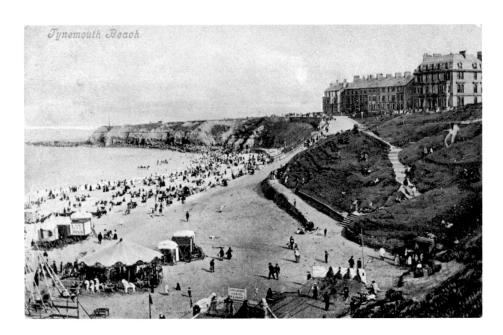

Lion Fountain and Longsands Before The Outdoor Pool

In the bottom-right corner of the picture, which dates from before August 1907, can be seen a number of people standing in front of the Lion Fountain, built into the bank side in 1863. This popular fountain, fed from a natural 'healthy' spring, later fell out of use. It was buried by sand and almost completely forgotten, although water from the spring still flowed out through the sands. In 2010 it was excavated for a few days as part of a charity event, with people given the opportunity to dig it out after making a contribution to a lifeboat charity.

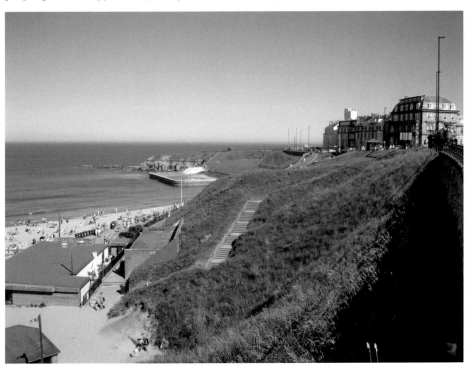

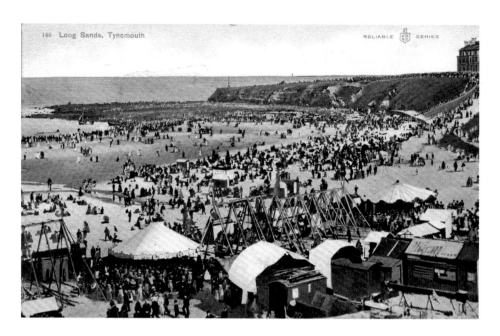

Longsands from the Aquarium

In 1908 Tynemouth Longsands offered a wide range of attractions to visitors. At the edge of the high-tide line are rows of bathing machines that could be wheeled out into the sea and bashful female bathers could descend inside the covered hut to bathe in their own private pool, out of the gaze of others. Behind the huts offering a wide range of refreshments and beach essentials are two sets of 'shuggy boats' or large shared swings in the shape of rowing boats. Today the main recreation is surfing or watching from the café.

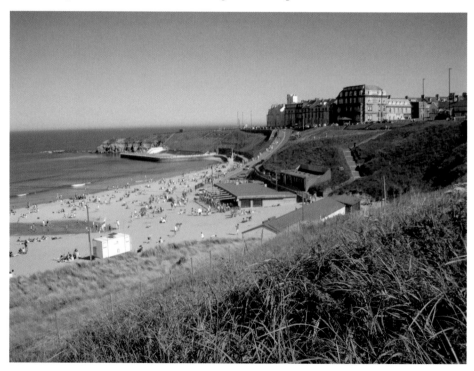

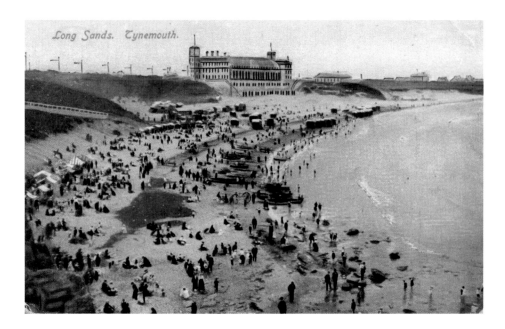

Longsands and the Palace

Before the outdoor pool was built, the beach on Tynemouth Longsands was popular with swimmers, and people rowing boats and using bathing machines as seen in the 1908 view. At that time swimmers who did not like swimming in the sea could use a pool formed out of the rocks at Table Rocks, between Cullercoats and Whitley Bay, about two miles to the north. In the background, dominating the beach is the Tynemouth Palace, better known in later years as the Plaza.

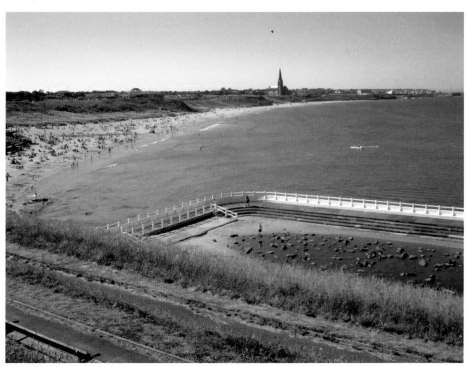

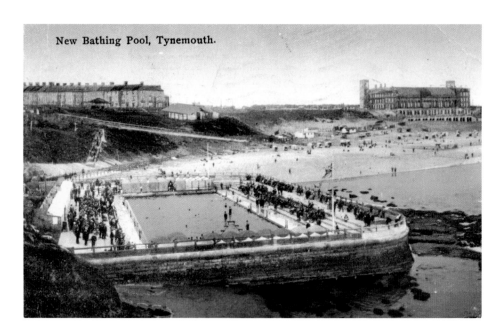

New Bathing Pool, Tynemouth.

New Bathing Pool, Tynemouth

Tynemouth Pool was opened in 1925, not long before this postcard was sent in August 1928. At first only tents were provided and it was a few years before permanent changing facilities followed in 1927. It proved an instant success and remained popular for decades, used for both swimming and diving competitions. When the new indoor pool was built at Preston Village in the 1970s it fell out of use and became a maintenance and safety problem. It was eventually filled with sand and rocks to make rock pools, to overcome safety issues.

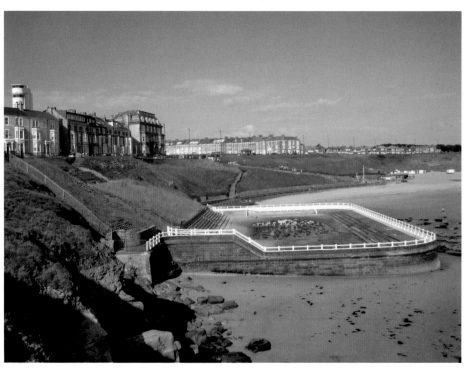

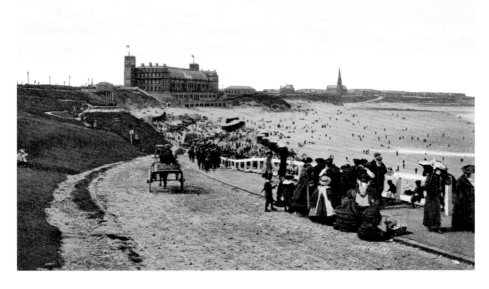

Longsands from the South Ramp

In this view from before September 1910, a horse and cart is travelling down the south ramp towards Tynemouth Longsands to make a delivery on the beach. A large group of well dressed children seem anxious to join the crowds already on the beach beside the rows of bathing machines. There are four buildings visible above the beach, namely, from left to right: the Palace, the shops and toilet block opposite Tynemouth Park, Beaconsfield House and St George's Church with the spire beyond. Cyclists prepare for the C2C cycle challenge below.

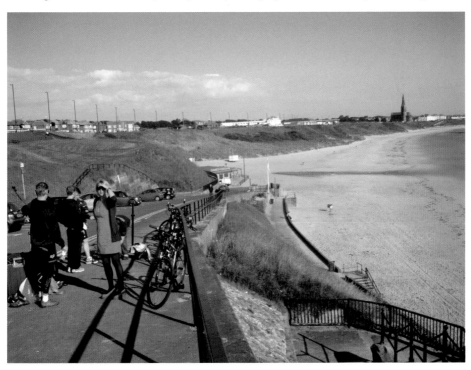

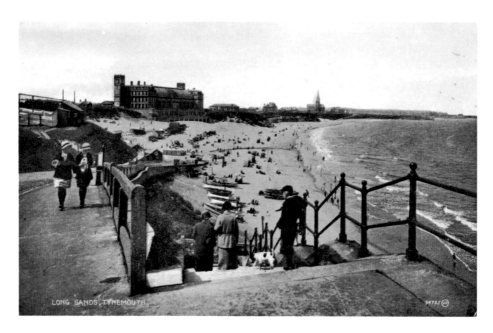

LONG SANDS, TYNEMOUTH

Tynemouth Longsands from the North in the 1920s

Looking north towards the Tynemouth Palace, the bathing machines that were very evident in earlier pictures have disappeared and the fashions have changed, with the ladies on the ramp wearing the latest 1920s designs. The postcard is postmarked September 1926, well before surfing became one of the main attractions for the adventurous visitor. From the number of rowing boats on the beach it seems rowing must have been a popular pastime, especially as it was one of the main spectator sports of its time.

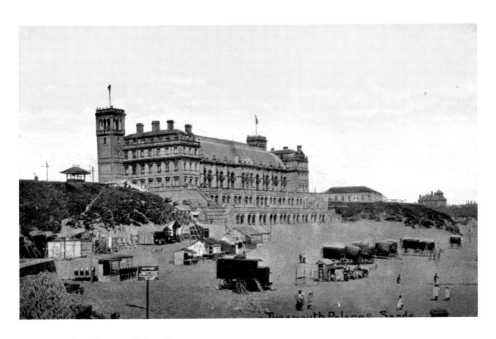

Tynemouth Palace and Sands

Tynemouth Palace was a massive structure when seen from the beach. It had at least six separate floors with individual frontages onto both the beach and Grand Parade. In the foreground there is a close-up view of one of the bathing machines that could be wheeled into the sea to allow the user their own individual private dip in the healthy, and no doubt bracing, North Sea. To the right beyond the hut there are a number of donkeys having a break from activities. Nothing remains of the structure today.

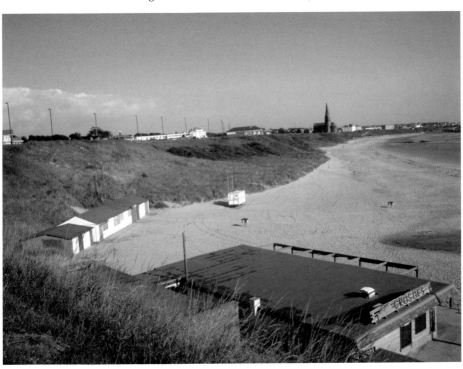

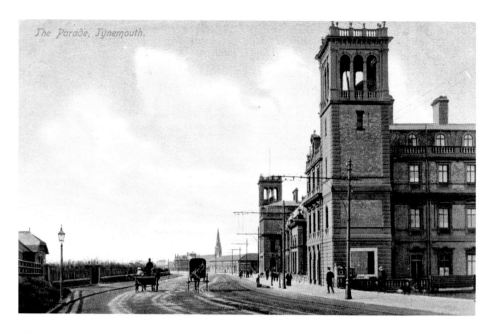

The Parade, Tynemouth.

The Parade, Tynemouth

Looking north along Grand Parade in the early 1900s Tynemouth Palace dominates the street and overlooks Tynemouth Park on the left, with its lodge, gateway and railings. Although there are no trams in view, the poles to support the overhead cables can be seen in front of the Palace. Horses and carriages seem to be the main form of transport, keeping clear of the tramlines. St George's spire can be seen in the background. The lodge and railings for Tynemouth Park have gone but the gateposts still exist.

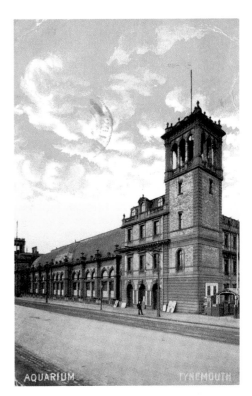

Aquarium, Tynemouth

The building, seen here before 1906, was often referred to as the Aquarium rather than the Palace. The man in front of the building seems to be looking at his watch and is perhaps waiting for a tram to arrive on the tracks immediately in front of him. The Blue Reef Aquarium was built in the 1980s and continues the tradition of tourism in Tynemouth. There was also another aquarium in the area at the Dove Marine Laboratory, which still carries out research into sea creatures.

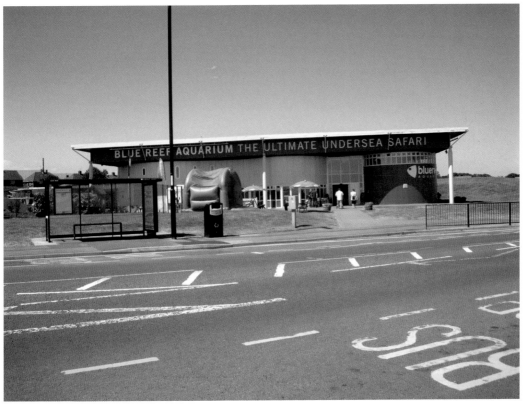

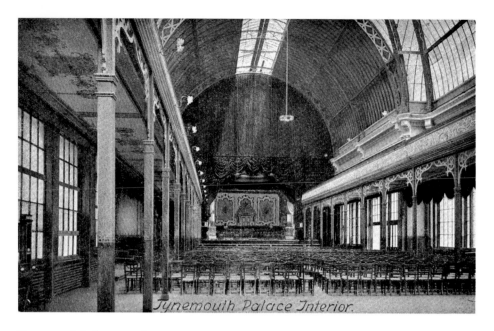

Tynemouth Palace Interior.

Tynemouth Palace Interior

The Palace opened in 1878 as the Tynemouth Aquarium and Winter Gardens and over its lifetime was never a success. In later years it has been variously called Tynemouth Palace, Gala Land and Tynemouth Plaza. It has been used for a wide range of activities including a concert hall, tea rooms, a roller-skating rink, a venue for dog shows, an amusement arcade, an indoor market and Maxwell's night club. It burnt down in the 1990s in a massive fire that burnt for sixteen hours and as the land was contaminated the site had to be covered and fenced off for public safety.

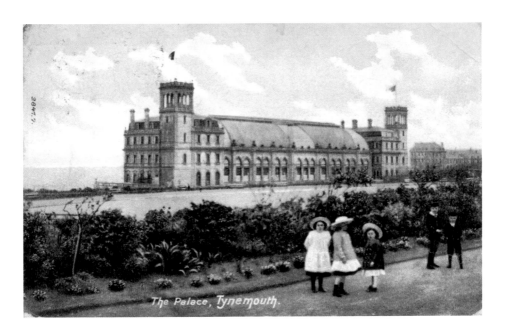

Tynemouth Palace from the Park

Tynemouth Park and lake was dominated for over a century by the bulk of the Tynemouth Palace, or Plaza as it became known in recent years. It did provide some indoor shelter when the weather was inclement and in later years part was given over to an amusement arcade. There was also a crazy golf course beside the Plaza for many years, now replaced by a much bigger and more challenging adventure putting green in Tynemouth Park on the site of some old tennis courts. The boating lake is well used by model boat enthusiasts.

The Park, Tynemouth

Tynemouth Park Looking North

Tynemouth Park was originally laid out as a recreational ground with a bandstand, large lake and bowling greens in 1893. The park was extended in the 1930s, when the pavilion and tennis courts were added to complement the formal decorative gardens. The lake has been popular for wildlife as well as for use by rowing boats and model boats. In 2010 it was fully dredged to remove silt and algae that were a threat to the wildlife.

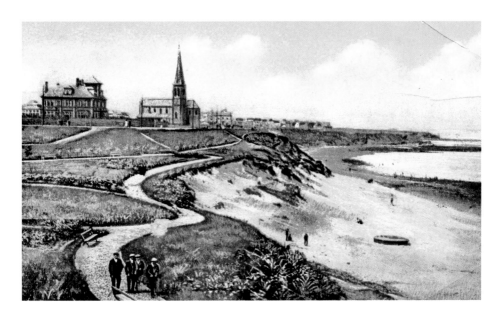

Tynemouth Banks

Tynemouth Banks is the area immediately north of the Plaza complex. It was formerly the valley of the small stream called Kenner's Dene, which flowed into the sea at this point. There is a street to the west of the railway called Kennersdene named after the stream and Kennersdene Farm used to be to the west of Tynemouth Park. Tynemouth Banks was laid out as an attractive landscaped garden area with paths in the early 1900s by Tynemouth Council and is still used today.

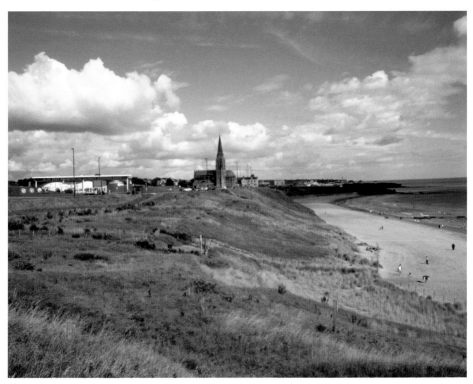

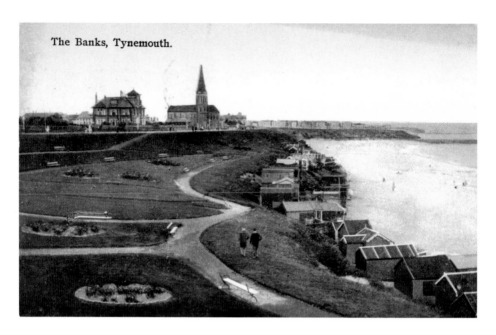

The Banks, Tynemouth.

The Banks, Tynemouth with Beaconsfield House

By the 1930s the beach was full of beach huts built by individual owners to a general plan set out by the council. They were used by families from nearby towns who would visit the beach on a regular basis. They were cleared in 1940 when the army took over the beach to prepare for a potential German invasion. Beaconsfield House was built as a private house in 1882 by John Henry Burn, a local coal owner. It was used as a Dr Barnado's Home from 1945 and demolished in 1957. The Park Hotel was built in the 1930s overlooking the Banks.

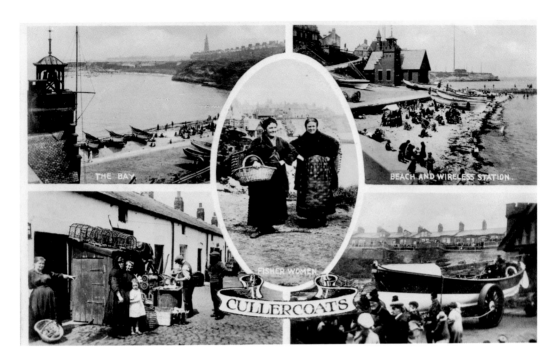

Cullercoats Views

Fishing dominates the views of Cullercoats contained in this sepia postcard, postmarked 1939. It has fishing boats on the beach, fisherwomen in the centre picture, and the cottages where they lived to the bottom-left. In the bottom-right picture we see the launch of a lifeboat, manned by fishermen, to rescue those in distress. The wireless station also communicates with the fishermen at sea. The picture below features three fisher lasses dressed in the traditional clothes of the day.

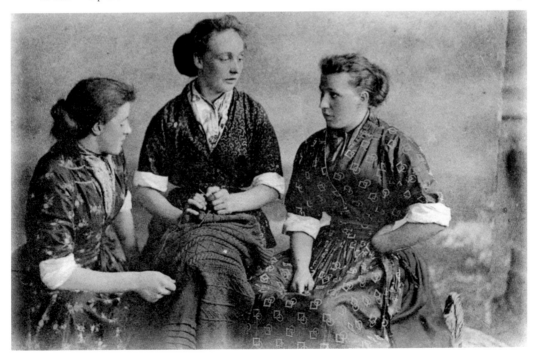

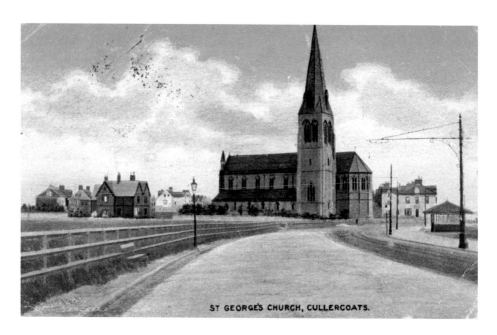

ST GEORGE'S CHURCH, CULLERCOATS.

St George's Church, Cullercoats

The church is a Grade I listed building built in 1884 by J. L. Pearson for the sixth Duke of Northumberland as a memorial to his father. It was consecrated by Bishop Wilberforce who was a relation of William Wilberforce, the anti-slavery campaigner. There was a temporary church on the site before the main church was opened and this prefab had a painting of St George on the side. The war memorial to the First World War dead, which included the names of Sir James Knott's two sons, was stolen in recent years for scrap metal.

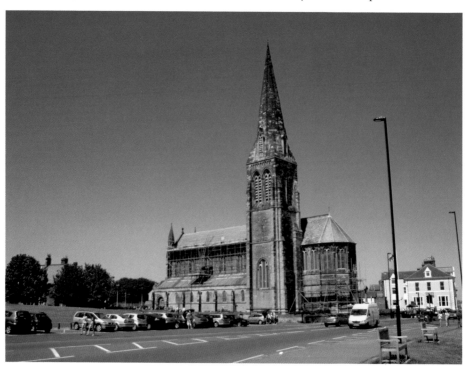

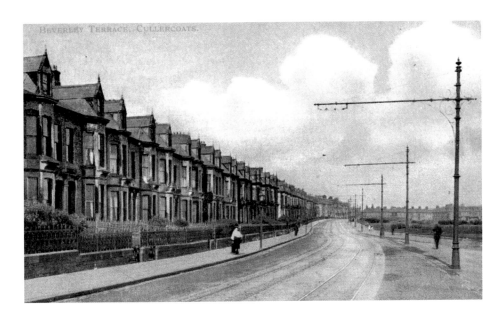

Beverley Terrace, Cullercoats

Beverley Terrace is seen here before July 1907 and has not changed a lot in the last 100 years although the tramlines and gantry supports have disappeared, as well as the railings to the front gardens. These very imposing houses were developed as early commuter houses for the rich during the 1870s, on land owned by the Duke of Northumberland. They all had three taps for water; hot, cold and seawater, which was seen as very healthy at the time. Beverley Terrace was named after the town in Yorkshire where the Duke also owned a lot of land and property.

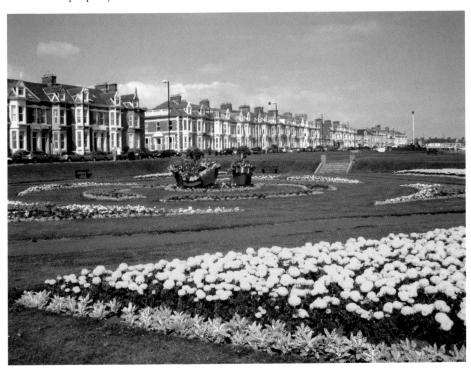

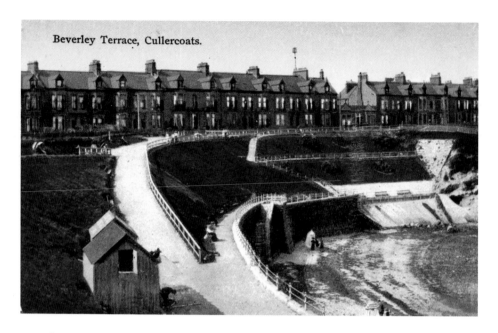

Beverley Terrace, Cullercoats.

Beverley Terrace, Cullercoats and Beacon House

This is the northern part of Beverley Terrace seen from above the bay in around 1910. The single-storey house in the terrace is Beacon House which has a large mast in the back garden. Beacon House was built about 1870 and was single storey to allow a beacon and a mast at the front and rear of the building to be seen by craft entering the harbour. It was double width to compensate for the lack of a second storey. Each mast had eight guy ropes to allow the light to be lowered for maintenance. Beach chalets have recently been erected above the bay.

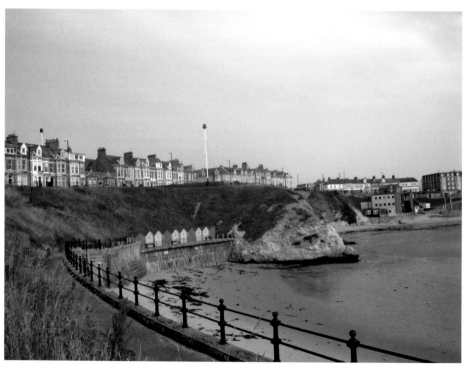

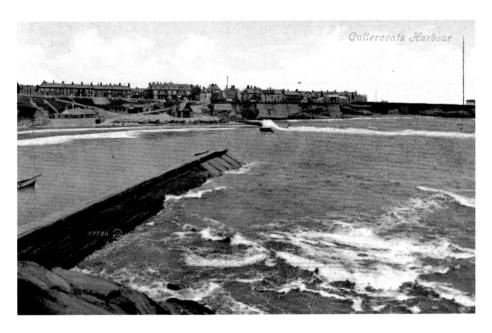

Cullercoats Harbour Looking North over the South Breakwater

Pictured before 1908, both breakwaters are shown here. Protecting the harbour from the heavy storms that lash the coast, over the years the breakwaters have been damaged a number of times. John Dobson, the famous Newcastle architect, restored the piers in the 1840s. In recent years, when the north breakwater was breached a temporary repair was made. Major repairs to the South Pier were commenced, as seen in the view below taken in August 2011.

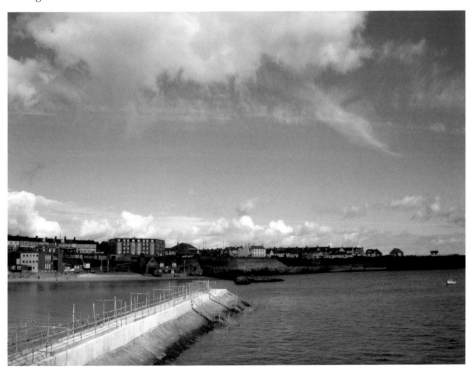

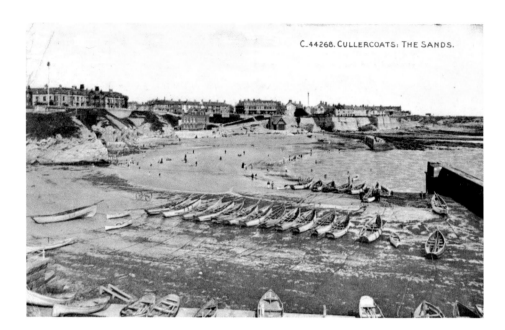

C_44268. CULLERCOATS: THE SANDS.

Cullercoats: The Sands

A large number of fishing boats are drawn up onto the sands of the bay at low tide, in this view from around 1915. The original area for storing boats was on land above the south pier leased from the Duke of Northumberland, where the picture was taken, close to Tynemouth North Point with its smugglers' cave. This land was previously used by salt pans. Seawater was pumped up from the shore and boiled in salt pans, using poor quality pan coal from the local collieries. The salt was used to preserve fish and other food. The boat park is now in the village.

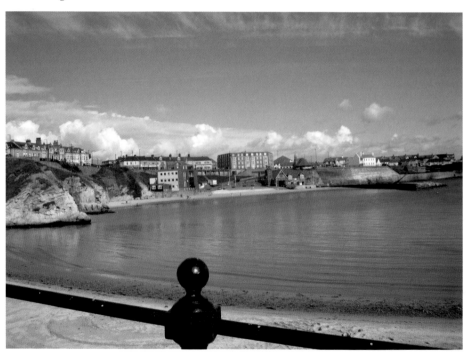

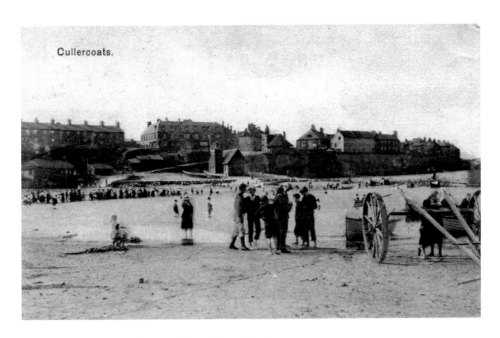

Cullercoats.

Cullercoats Bay from the Beach, Looking North-west

This early view, from before October 1905, shows children playing on the beach beside the large wheels of a carriage used to transport the fishing cobles into the sea. In the background, in front of the seawater baths, a large number of well dressed people are standing along the edge of the shore and seem to be waiting for something to happen. Wheeled trailers are still used today but are towed behind tractors.

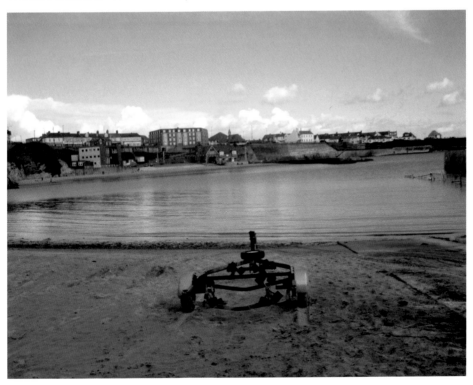

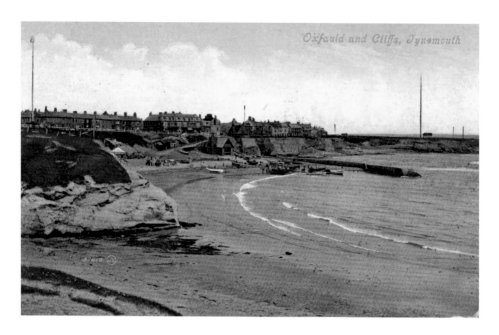

Oxfauld and Cliffs, Cullercoats

The title of the postcard refers to the Oxfauld, a gully beside the cliffs in King Edward's Bay in Tynemouth. The picture, taken before June 1909, is actually of Cullercoats Bay with, in the distance, a mast on Brown's Point or Marconi Point. This point, originally known as The Howling, was where fishermen hung out their washing to dry. Cullercoats Radio Station was opened in 1906 by the Amalgamated Radio Telegraphy Company and licensed for W/T ship communications. They built a 220-foot high wood lattice mast. The station closed in 1996.

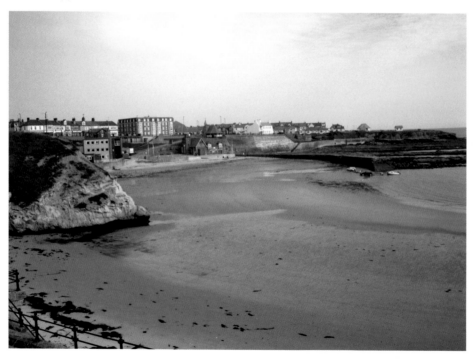

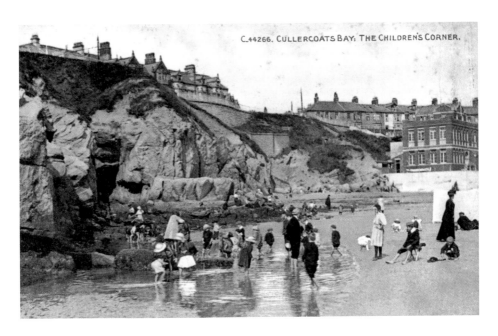

C.44266. CULLERCOATS BAY: THE CHILDREN'S CORNER.

Cullercoats Bay: Children's Corner

Children are seen playing outside one of the many caves on Cullercoats Bay, in what is described as 'Children's Corner'. One of the caves was known as 'Fairies' Cave' and was over 150 feet in depth. In the past it was used for storing smuggled goods. The caves in Cullercoats were used at times by local smugglers trying to avoid the excise men on the River Tyne, at Newcastle and Blyth. In 1722 a customs official was murdered by two men who operated an illicit brandy business. An excise man was based in Cullercoats at Cliff House.

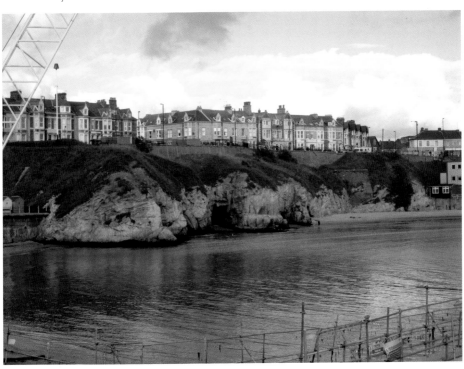

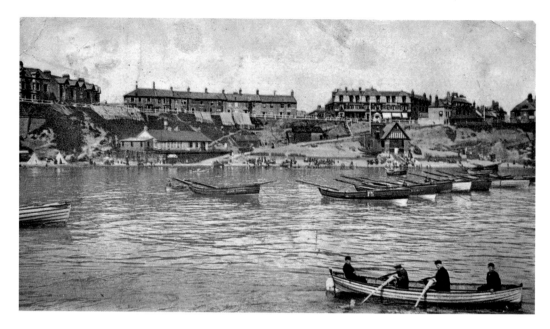

Rowing Boats at Cullercoats

The postcard is dated 17 September 1904 and shows what looks like a pleasure rowing boat in the foreground with a fishing coble in the centre of the picture. Cullercoats became a popular resort for visitors following the opening of the railway station in 1882 linking it to Newcastle and other Tyneside towns. The electric trams also reached Cullercoats in 1900. Before that time fishing was the main industry, having taken over from salt panning and coal and limestone export from the harbour.

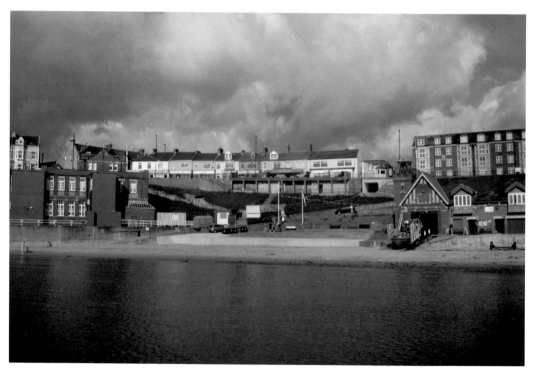

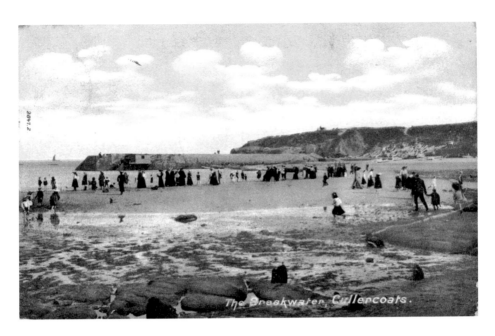

The South Breakwater, Cullercoats Bay

The south breakwater is seen here in around 1906. It is interesting to note that there is a timber cabin built onto the west side, close to the seaward end, with steps leading down from it into the sea. There are a number of people on the steps as well as on the platform that supports the cabin. There are a lot of well dressed ladies standing on the shore taking in the air – the long dresses do not seem to be sensible attire to walk across wet sands, very evident in the foreground. The breakwater was being reconstructed in 2011.

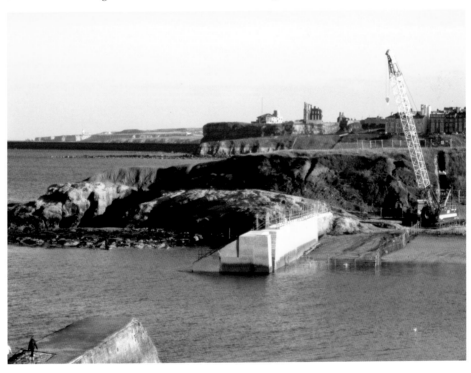

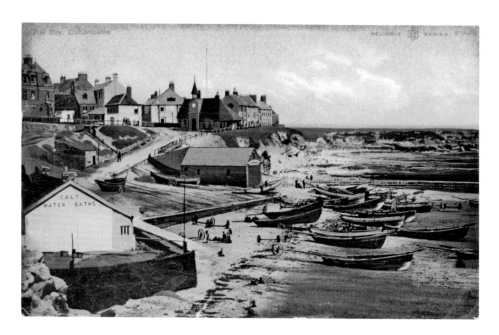

The Bay, Cullercoats with Saltwater Baths

The saltwater baths were built in 1807 by Richard Armstrong, on the site of the old salt pans. In publicity he said that the baths were refilled at every tide with seawater and that he provided commodious dressing rooms to serve the individual bathrooms. Bathing in saltwater was considered to be very good for your health and these saltwater baths could be heated for the customer as well. They proved very popular and Cullercoats was seen as a fashionable watering place. Dove Marine Laboratory was built on the site in 1908.

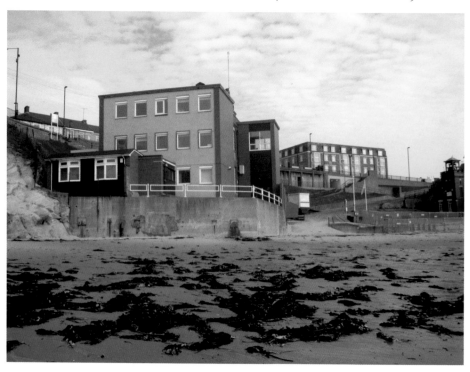

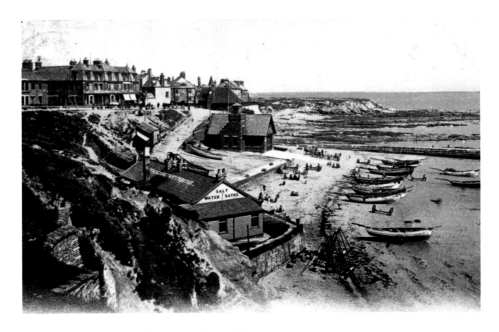

Cullercoats Bay with Saltwater Baths and Hut

The saltwater baths, seen here before July 1903, have had a hut built on to the south side and in the background the lifeboat station has been rebuilt – the bell tower was installed in 1896. There are also swings built onto the beach in front of the baths. In the background, the Bay Hotel dominates the promenade and immediately to the north of it stands the Newcastle Arms fronting on to Front Street. The Bay Hotel was previously called the Hudleston Arms, after a family who owned a lot of land in the village.

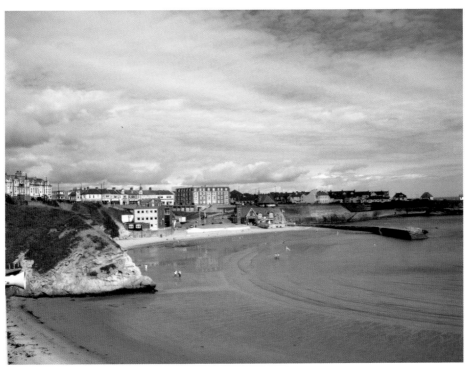

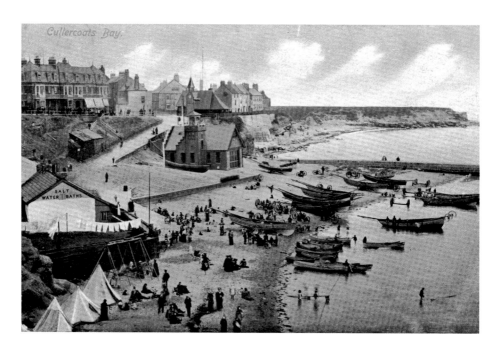

Cullercoats Bay with Tents on Beach

The impressive tents on the beach date from before May 1905. In the background there is no evidence of development on Brown's Point or beyond, where the Marden Burn marked the boundary of the village. On the promenade above is the Adamson Memorial Fountain to the memory of local man Lieutenant Commander Bryan John Huthwaite Adamson, who was captain of his first and only vessel, named *The Wasp*. It disappeared without trace in 1887 with the loss of eighty people, near Singapore. *The Wasp* was built in Newcastle.

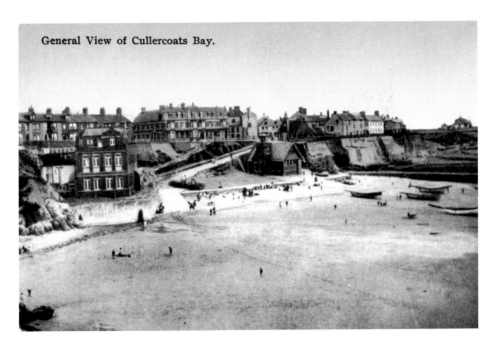

General View of Cullercoats Bay.

View of Cullercoats Bay with the Dove Marine Laboratory
The 1908 Dove Marine Laboratory started life as a hut beside the saltwater baths. It was established by Revd William Hudleston, who set up the laboratory 'for the furtherance of marine biology'. Armstrong College in Newcastle had a laboratory in Cullercoats, established in 1897, to study the coastal waters. After it burnt down in 1904, Wilfred H. Hudleston gave the land and paid towards the building of a new laboratory. It was named after one of his predecessors, Eleanor Dove, who married Revd Curwen Hudleston in 1792.

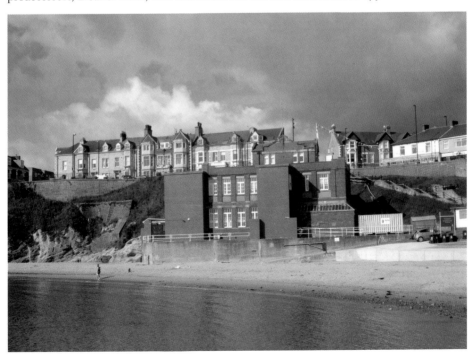

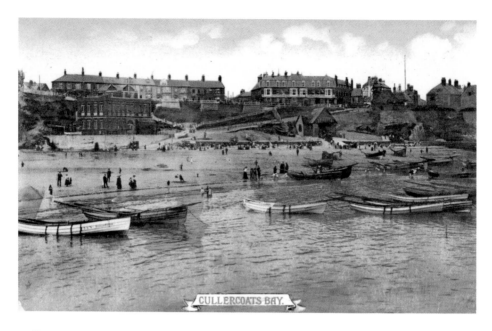

CULLERCOATS BAY.

Cullercoats Bay from the Pier

In this picture the Dove Marine Laboratory appears to be under construction and the lifeboat house is yet to receive its bell tower, suggesting the image dates from before 1908. The low building on the skyline, to the left of the laboratory, is the apparatus house. The rocket garage below was built in 1867 as an apparatus house for Cullercoats Volunteer Life Brigade, the second in the country after Tynemouth. The life brigade used rocket-fired lifelines to reach shipwrecks and then rescued people by breeches buoy.

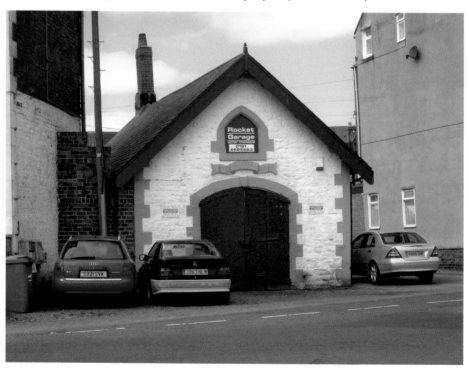

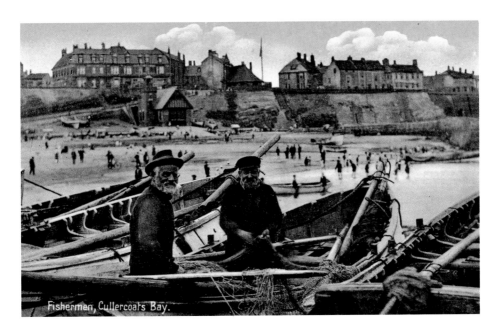

Fishermen, Cullercoats Bay.

Fishermen at Cullercoats Bay

Cullercoats, with its natural harbour, has been a home for fishermen for hundreds of years and still has a small number of working boats. Following the demise of coal and limestone exports and salt production in and around the bay, fishing developed to become the main industry, until the railway transformed the village into a commuter and tourist resort. The fishermen lived in traditional whitewashed fishermen's cottages centred on Front Street. The present boat park for the village now occupies a site on Front Street.

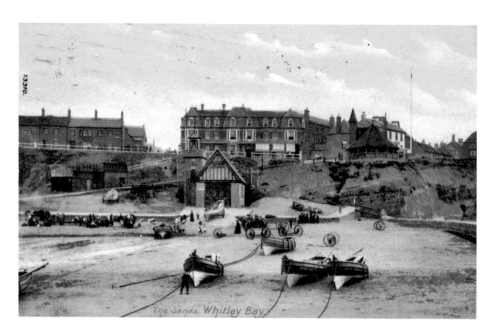

The Sands, Whitley Bay

The Sands, Cullercoats

This is clearly Cullercoats, not Whitley Bay as the caption on the postcard states. It dates from before December 1905. The Hudleston Arms, later the Bay Hotel, is where Winslow Homer lived between April 1881 and November 1882 and he used 12 Bank Top as his studio. He painted many scenes around the village, as well as using many of the local people as models for his paintings. Others to paint here include local artists Thomas Miles Richardson, Ralph Hedley and John Wilson Carmichael. Winslow Court was built on the site of the Bay Hotel in 2004.

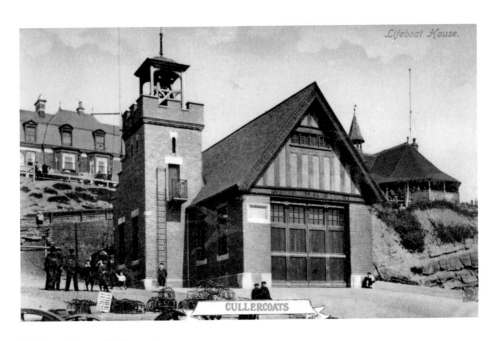

Lifeboat House, Cullercoats

The first lifeboat at Cullercoats was called the *Percy* and was bought by the Duke of Northumberland in 1852. The Royal National Lifeboat Institute took over the operation in 1853 and built a small boathouse. This was replaced in 1896 by the present boathouse that was built to house the 37-foot self-righting lifeboats. In 1861, the second *Percy* was dragged on its carriage several miles by horses, men and women, to Briar Dene, to be launched to rescue the crew of *Lovely Nelly*. The painting *The Women* by John Charlton records this event.

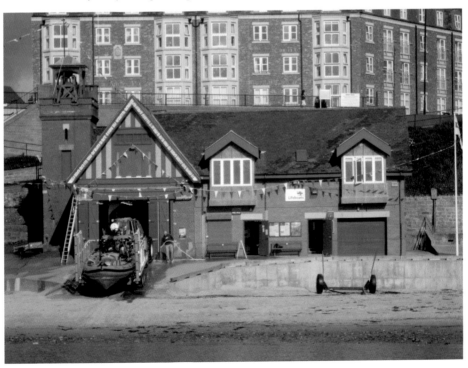

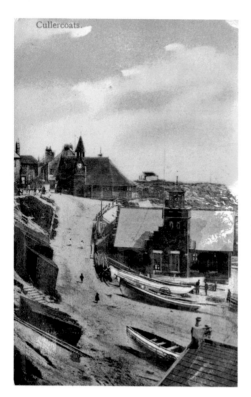

Cullercoats.

Cullercoats Watch House and Lifeboat Station

The watch house for the Cullercoats Volunteer Life Brigade was built in 1879 and designed by F. W. Rich as a lookout house. It offered shelter to the lifeboat men who previously had to stand out in the open beside Cliff house. The Board of Trade provided the £385 needed. The clockworks came from a clock that had previously been on the end of a private house, Dial House, for over twenty years. The clock dial was provided by Tynemouth Corporation. Today the watch house is used as a meeting and recreational room for members and local residents.

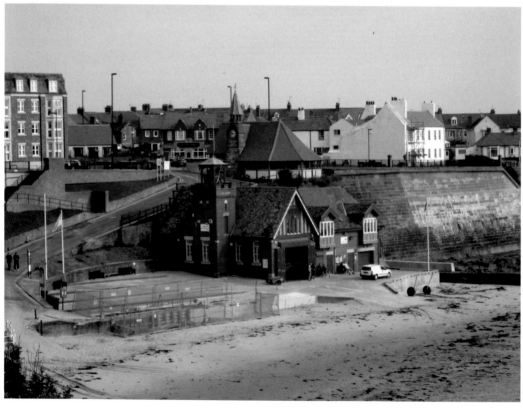

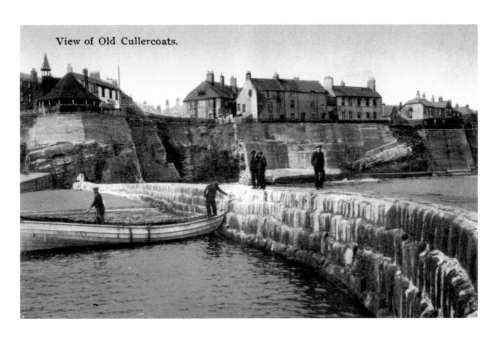

View of Old Cullercoats.

View of Old Cullercoats from the North Breakwater

In 1929, Tynemouth County Borough Council's Town Improvement Commission asked the Borough Surveyor to assess the recent storm damage to cliffs in front of Cliff House, following a petition from residents in Cullercoats. He advised that a sea wall should be built and damaged cottages should be demolished at the same time. Dial House, or Clock House, was demolished around 1936. This was the last building in the Bank Top terrace of properties continuing south from Cliff House. It had a clock face set in the side, installed around 1859.

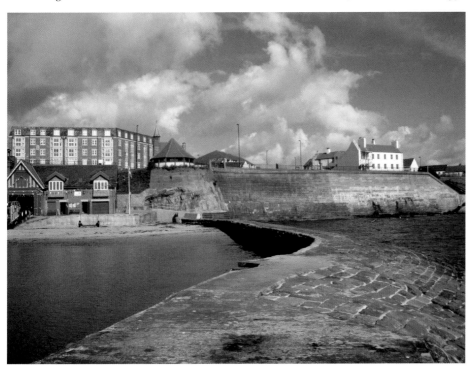

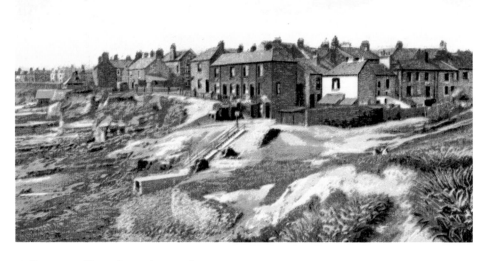

Cullercoats Village from the North-east

The edge of the village was defined by the Marden Burn, culverted before this view was taken. One of the village's oldest buildings, Dove Hall, the original home of the Dove Family, stood here. Locals called the three-storey building Sparrow Hall as the carving above the door looked more like a sparrow than a dove. It was said to have been built in 1682 and originally stood in its own grounds and looked out to sea. Later, buildings were built up around it, known as Back Row. It is thought that it was demolished after 1969 to make way for a seafront village green.

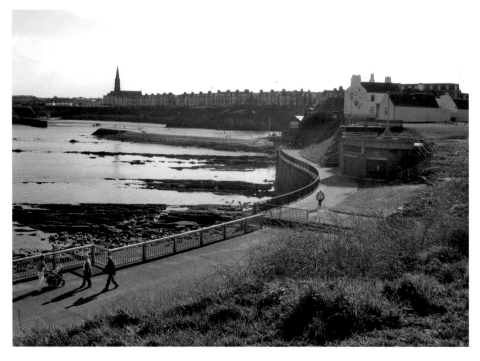

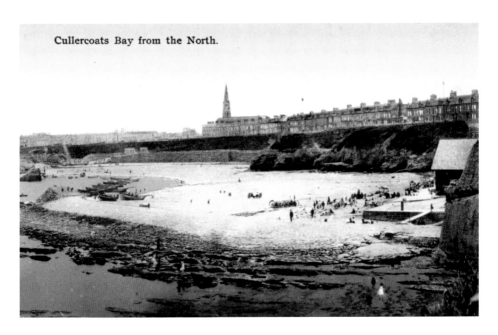

Cullercoats Bay from the North.

Cullercoats Bay from the North

This view of Cullercoats Bay, with its deep blue sea and sky, illustrates why the area became a magnet for artists over the years. Apart from Winslow Homer, other famous artists who painted here include William Henry Charlton, John Wilson Carmichael, Robert Jobling, John Falconer Slater, Agnes Pringle, Captain John Robert Mather, who lived at 49 Beverley Terrace, and Henry Hetherington Emmerson, who lived in John Street. Occasionally, strong winds can lead to the breakwaters having to earn their name as they are battered by waves.

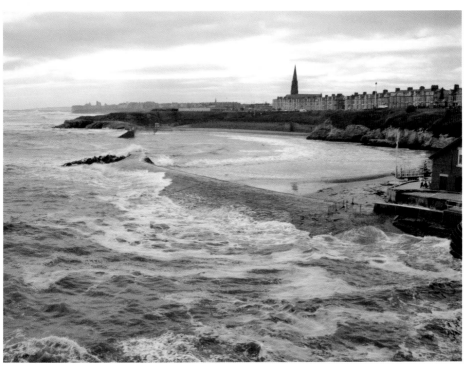

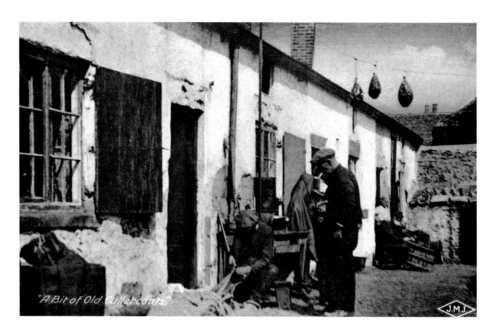

A Bit of Old Cullercoats

Two fishermen are seen here repairing nets outside the front door of a typical fisherman's cottage. Most of these cottages were based around Front Street and Back Row. They were modest in size and lacked modern sanitary facilities. They were cleared and replaced by modern housing in the 1970s. The Queen's Head on Front Street dates from 1828. It was refurbished by William Thompson who claimed it would be 'a desirable retreat during the bathing season'. It was altered in 1865 and the present building dates from the 1930s.

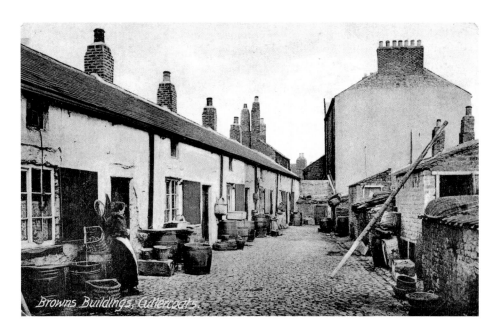

Brown's Buildings, Cullercoats

Brown's Buildings are typical whitewashed, single-storey fishing cottages. They were built in 1836 by John Brown, a local shopkeeper and were behind Front Street with access off Simpson Street. They were cleared in the 1970s to make way for the more modern houses on the west side of Front Street, which were rendered white in memory of the cottages. Most of the cottages were located around John Street and a reminder of them can be seen in Simpson Street where later housing was built to match their design.

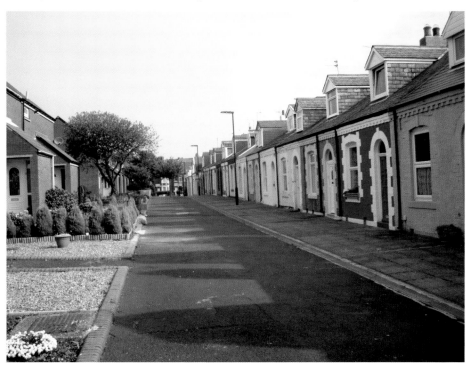

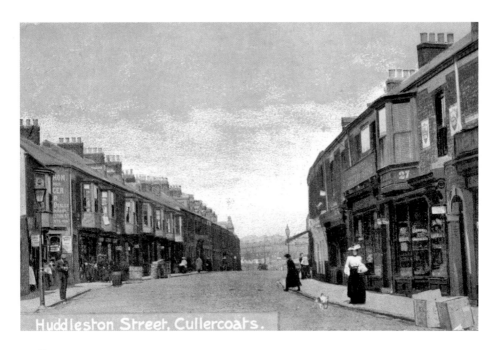

Huddleston Street, Cullercoats.

Hudleston Street

Hudleston Street is misspelt in the postcard. It refers to the well known family who over the years made a major contribution to the village. Revd Curwen Hudleston married Eleanor Dove in 1742. She was the heiress of John Dove of Dove Hall. A lot of local streets are named after this family including John Street, Eleanor Street and Dove Street. The Doves were Quakers, as were a lot of their neighbours and there was a Quaker burial ground originally at the north end of John Street. Hudleston Road, now Hudleston courtyard, was west of Front Street.

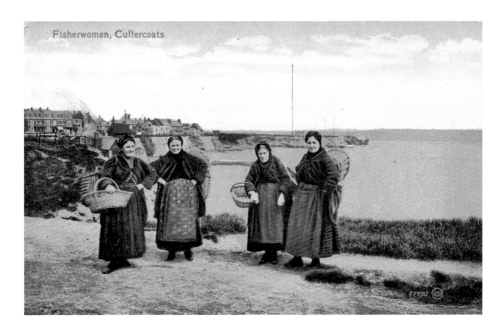

Fisherwomen, Cullercoats

Fisherwomen, Cullercoats

Behind the traditionally dressed fisherwomen is Marconi Point. The Post Office took it over in 1912 to provide communication with coal carriers on the north-east coast. The Marconi equipment was used to contact trawlers as far as 200 miles away. The station was rebuilt in 1916 and the other buildings were rebuilt in 1926. The pine masts were replaced by a 133-foot latticed steel tower in 1934. In later years it relayed messages from oil rigs in the North Sea. It closed in 1996 and the buildings have been converted into a private house.

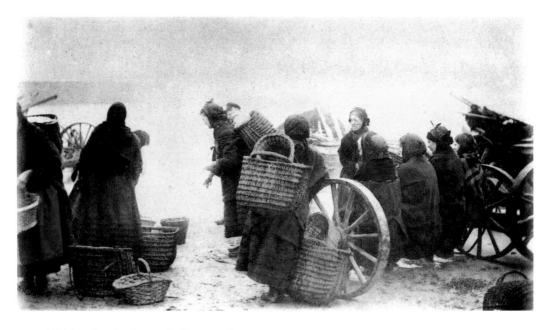

Waiting for the Boats, Cullercoats Bay

The Cullercoats fishwives tended to wear the same 'uniform' that included a print bodice, a coloured neckerchief and a blue flannel skirt which they added to over the years by adding horizontal pleats to the skirt to build it up in size. They carried a creel or wicker basket with a flat back and curved front to carry the fish in ready for sale. They would use the train from Cullercoats to take the fish to Newcastle to sell. The Fisherman's Mission below was set up in 1931 by local fishermen. A Cullercoats coble carved in stone can be seen above the door.

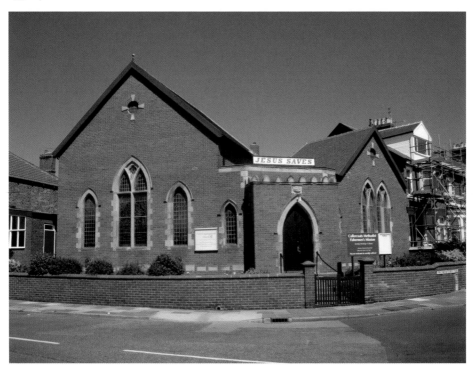

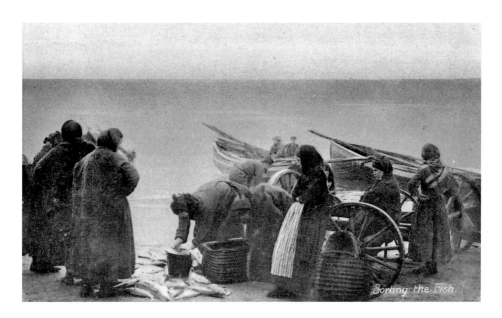

Sorting the Fish, Cullercoats Bay

This image dates from before September 1907. The fishwives are seen sorting the fish ready to be loaded into the wicker baskets, known as creels. The fishwives would help their husbands by searching for bait such as mussels, limpets and dog-crabs among the rocks, digging up sandworms, and then baiting the hooks ready for fishing. Cliff House, below, was built in 1768 for Thomas Armstrong who was a customs and excise officer but also described as a master mariner and smuggler. He kept the seized contraband, as well as his own, in the cellars below the house.

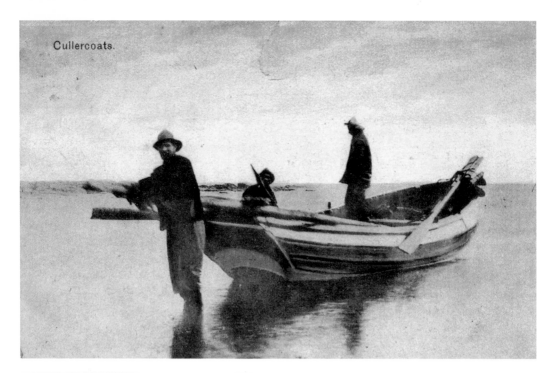

Cullercoats.

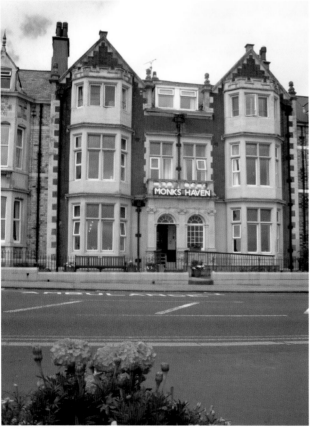

Fishermen in Cullercoats
This postcard was sent as a Christmas card on 24 December 1903. The vessel is a typical Cullercoats coble, which would cost about £30 to buy at the time. The main fish caught were haddock, whiting, cod, ling and turbot. Below is the former home of Sir James Knott, a wealthy philanthropist and shipowner who owned the Prince Shipping Line. He bought Monks' Haven before 1914 to use as a family home. He donated it to be used as a guest house for the Methodist Fellowship and in 1986 it was converted into a rest home for the elderly.

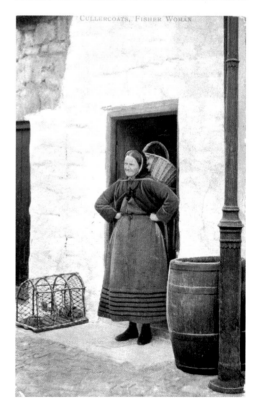

Fisherwomen

The lady above is described as an 'Old Cullercoats Fishwife.' The one pictured below is another fisherwoman. The traditional costume was described by Lillian Wasserman of Beverley Terrace in the *Arts Journal* of February 1887: 'print bodice with coloured neckerchief tucked inside, the blue flannel skirt, worn short, with a profusion of tucks – the more tucks a Cullercoats belle has the better the style she is counted – and the home knitted stockings and strong but neat shoes.'

Acknowledgements

Special thanks go to Diane Leggett for her help and encouragement and staff at the Local Studies section of North Tyneside Libraries, including Ian Brown and student Mathew Redmayne, for their help and for allowing me to use many of the photographs from the collection that they have built up since 1974. Many of the photographs used have been donated by members of the public and library staff are always on the lookout for additional pictures for their collection and to be made available to a wider audience through books like this. Most of the information for this book came from books and materials held by the Local Studies section. There are too many sources to mention individually but those worthy of a special mention are the excellent books produced by members of the Cullercoats Local History Society called *Cullercoats Remembered* and Eric Hollerton's *Tynemouth in Old Picture Postcards*. Information on Tynemouth Priory and Castle came from English Heritage's guidebook. In addition, all the local newspaper articles based on local postcards, published over the years by Local Studies staff, are a great source of information and inspiration for those interested in local and family history. Eric Hollerton, Alan Hildrew and Diane Leggett have been responsible for providing the majority of this information every week for many years.

Thanks go to Sarah Flight and Joe Pettican at Amberley Publishers for asking me to write the book and for their help in producing it.

Again many thanks go to my family, especially my wife Pauline for proofreading the text and putting up with being left to walk alone along the seafront as I disappeared to take yet another photograph. Also thanks to my sons Peter and David for their continued encouragement and support.

Ken Hutchinson
August 2011